IMAGES
of America
DUPONT

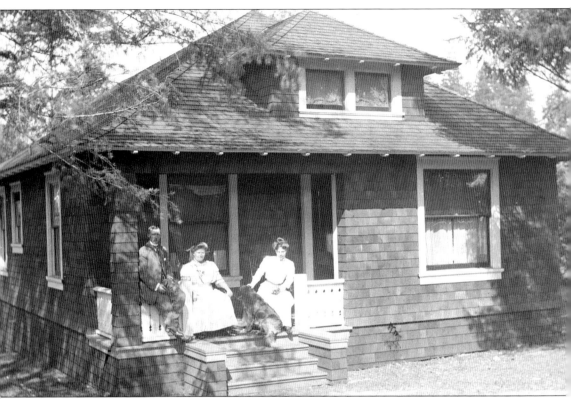

Carl and Klara Swederg relax on the front porch of their DuPont home with Mrs. Cox and their pet dog. A painting of this scene, "Village Home Mural" by Elizabeth Miller, is at the DuPont Historical Museum. The DuPont Company built over 100 bungalow-style homes in the 1910s, renting them to workers. These homes form the historic DuPont Village neighborhood today. (Courtesy of the DuPont Historical Museum.)

ON THE COVER: A "Little Eva" worker transports finished nitroglycerine with an "angel buggy" at the DuPont Powder Works plant. One of the most dangerous steps of manufacturing dynamite, the slightest misstep or jolt could send the worker heavenward. In 1909, the E.I. DuPont Company created the community of DuPont as a company town to house plant workers and their families. (Courtesy of the DuPont Historical Museum.)

Jennifer Crooks and Drew Crooks
with the DuPont Historical Society

Copyright © 2019 by Jennifer Crooks and Drew Crooks with the DuPont Historical Society
ISBN 978-1-4671-0281-0

Published by Arcadia Publishing
Charleston, South Carolina

Printed in the United States of America

Library of Congress Control Number: 2018953284

For all general information, please contact Arcadia Publishing:
Telephone 843-853-2070
Fax 843-853-0044
E-mail sales@arcadiapublishing.com
For customer service and orders:
Toll-Free 1-888-313-2665

Visit us on the Internet at www.arcadiapublishing.com

To the people of DuPont.

Contents

Acknowledgments		6
Introduction		7
1.	Beginnings	9
2.	DuPont Plant	27
3.	Company Town	53
4.	Community Life	75
5.	Schools	93
6.	Modern City	115
About the Organization		127

ACKNOWLEDGMENTS

This book is the product of a team effort. The authors thank the DuPont Historical Society for its support of the project, especially Carol Estep (president) and Lee McDonald (vice president). Estep and McDonald provided both unwavering encouragement and essential historical information and photographs that made the book possible.

We also thank the following: Erin L. Vosgien (acquisitions editor) and Caroline Anderson (title manager), of Arcadia Publishing, who kindly guided us through the writing/publishing process; May C. Munyan (author of *DuPont—The Story of a Company Town*) and Verne F. Newhouse and Carolyn Joringdal (editors of *Memories of DuPont*), whose books contain invaluable information on DuPont heritage; Eldon Estep, who took many of the contemporary photographs used in this book; Karen Johnson for proofreading the manuscript; and the Washington State Library staff for their assistance while we researched DuPont history.

A number of groups provided images for the publication. For the use of photographs we thank the Helix Design Group, Hudson's Bay Company Archives/Provincial Archives of Manitoba, Lacey Museum, Library of Congress, Quadrant, Tacoma Public Library, Washington State Archives, Washington State Digital Archives, Washington State Historical Society, and Washington State Library. Unless otherwise noted, all images appear courtesy of the DuPont Historical Museum. Thanks to the DuPont Company for permission to use some of the photographs it has given to the DuPont Historical Museum.

Finally, our special thanks go to Karen Crooks (mother of Jennifer and wife of Drew) for her constant and generous support of the project. We could not have done it without you!

INTRODUCTION

For at least 5,000 years people have called the DuPont area home. Its natural resources—the Puget Sound shoreline, Sequalitchew Creek, prairies, and woodlands—attracted Native Americans, Euro-American traders and farmers, and American settlers. A strategic location accessible by both water and land also encouraged people to live in the area from the earliest times to the present.

Since the early 19th century, one key constant in the area's history has been the importance of companies. These companies, or major organizations, include the Hudson's Bay Company (and its subsidiary Puget Sound Agricultural Company), DuPont Company, Weyerhaeuser Company (and its subsidiary Weyerhaeuser Real Estate Company), and the United States Army.

The Hudson's Bay Company (HBC), a British corporation formed in 1670, came to the DuPont area in 1833 with the establishment of the temporary Nisqually House. Its presence continued long into the 19th century with the first Fort Nisqually (1833–1843) and second Fort Nisqually (1843–1870). All these posts were commercial enterprises where the multiethnic employees of the HBC traded with Native Americans for furs and other items. Through its subsidiary, the Puget Sound Agricultural Company (PSAC), the HBC also operated a network of farming outstations in the region. At these outstations, the workers grew crops and raised livestock. HBC and PSAC activities were characterized by close cooperation—both commercial and social—with Native Americans, including the local Nisqually Tribe.

In a sense, the HBC era continued after the closure of Fort Nisqually in 1870. The last company official in charge of the post, Edward Huggins, retired from the HBC/PSAC. He became an American citizen and took a claim on the second Fort Nisqually site. For over 30 years, Huggins and his family ran a large farm there. The former company employee used old fort buildings (as long as they lasted) and maintained many old practices. For years, he even kept up a *Journal of Occurrences* just like the HBC did at Fort Nisqually and other posts. Furthermore, Edward Huggins recorded company life at Fort Nisqually and its outstations in numerous letters and articles.

Finally, due to declining health, Huggins sold his extensive landholdings in 1906 to the E.I. du Pont de Nemours Company. Founded in 1802 by French immigrant Eleuthère Irénée du Pont de Nemours, the DuPont Company manufactured gunpowder and explosives that were used for both civilian and military purposes. Later, the corporation became involved in chemicals and plastics and is presently known as DowDuPont.

The acquisition of land from Edward Huggins came at a time of rapid national expansion for the DuPont Company. The corporation decided to establish a manufacturing plant in the Pacific Northwest close to maritime and land transportation but somewhat remote (in case of accidental explosions). The factory, sometimes called the DuPont Powder Works, was completed in 1909. To house workers and their families, a temporary settlement of tar paper houses was built. Soon, a permanent village of bungalow houses, farther from the plant, replaced the temporary settlement, which was nicknamed "Old Town." The new village, named DuPont after the company, still exists as an important part of the modern city of DuPont.

In the early 20th century, DuPont was a true "company town." The DuPont Company owned all houses and commercial buildings, but businesses were privately run. A close-knit community developed, with strong ties between employers and employees. Every Thanksgiving, the company gave away turkeys to workers and their families. Also, streets in DuPont were named after people, places, and businesses associated with the DuPont Company. One example is Brandywine Avenue, named for Brandywine Creek in Delaware, where the first DuPont Company plant was built in 1802. Another is Hercules Street, named for a company subsidiary called the Hercules Powder Company.

In 1951, the DuPont Company sold the DuPont village houses to residents, and the community incorporated as a town. The DuPont plant continued in operation for another 25 years. Then, in 1976, the company closed its explosives manufacturing plant because of changing markets. It sold its landholdings in the area to the Weyerhaeuser Company, which was founded in 1900 by Frederick Weyerhaeuser. This corporation became one of the largest forest products companies in the world and remains today a powerful economic entity.

At first, the Weyerhaeuser Company intended to build an export facility for wood products on its DuPont property. A combination of world market conditions and environmental issues caused the corporation to change its direction. Instead, the company focused on land development in DuPont. The property was transferred to a subsidiary, the Weyerhaeuser Real Estate Company (WRECO), which plunged ahead with an ambitious plan to create the Northwest Landing development, including a combination of residential, industrial, and commercial sections. Quadrant, a subsidiary of WRECO, would be responsible for the housing part of the project.

The City of DuPont approved this plan in 1989, and it was implemented in phases (including the essential cleanup of industrial pollutants left behind by the work of manufacturing explosives for over 70 years). Businesses and houses sprouted in Northwest Landing, along with the necessary infrastructure, such as roads. The population grew rapidly as DuPont became a modern city. Still, the commitment by many to preserve the area's heritage remained strong.

Since 1917, another "company" has had a strong impact on DuPont. Camp Lewis was established near DuPont in that year. This US Army base was named after Meriwether Lewis, of the famous Lewis and Clark Expedition (1804–1806). In 1927, Camp Lewis became Fort Lewis. North of the post, an airfield was officially opened in 1930, which later became a US Air Force base. First known as Tacoma Field, in 1940 the facility was renamed McChord Field after William McChord, a military aviator who died in a 1937 airplane accident. In 2010, Fort Lewis and McChord Air Force Base merged to form Joint Base Lewis–McChord (JBLM).

Over the years, the social and business ties between DuPont and the nearby military facilities have been close. Many soldiers and their families have been part of the community. For much of the 20th century, the schools of DuPont and Fort Lewis were interconnected. Presently, numerous residents are active or retired military. It seems appropriate that a park in the downtown section of Northwest Landing, Ross Plaza Park at 1500 Ross Loop, is dedicated both to Charles Ross Jr., an HBC employee, and his family and to World War II Medal of Honor recipient Wilburn K. Ross. The Hudson's Bay Company and the United States Army—along with the Weyerhaeuser Company and, of course, the DuPont Company—have all shaped the story of DuPont.

One

Beginnings

DuPont, Washington, has a rich history. For thousands of years Native Americans lived in the area, including a Nisqually village that existed near the mouth of the Sequalitchew Creek at Puget Sound. Life there centered on a complex round of seasonal fishing, hunting, and plant gathering.

Lasting Euro-American contact came with the arrival of the Hudson's Bay Company, a British corporation that operated posts across what are now Canada and the US Pacific Northwest in the 19th century. HBC employees traded with Native Americans for furs and other products.

In 1833, the HBC established a temporary post, called Nisqually House, near the mouth of Sequalitchew Creek. Later that year, the company set up Fort Nisqually, a more permanent post inland. Five years later, the HBC created the Puget Sound Agricultural Company as a subsidiary to handle farming operations in the region. Fort Nisqually served as a center of PSAC activities, with farming becoming more important than fur trading over time.

American missionaries operated a Methodist-Episcopal mission, including a school for Native American children, near Fort Nisqually from 1839 to 1842. In 1841, the United States Exploring Expedition, led by Lt. Charles Wilkes, visited South Puget Sound as part of its journey around the world.

In 1843, Fort Nisqually was relocated a mile inland to a site on the south bank of Sequalitchew Creek. William Tolmie, new commander of the post, oversaw the move. An 1846 treaty divided the Oregon Country between Great Britain and the United States at 49 degrees north latitude. Fort Nisqually and the surrounding area fell under American rule, but the possessory rights of the HBC/PSAC were protected by the treaty.

William Tolmie left Fort Nisqually in 1859 for Fort Victoria, leaving Edward Huggins in charge of the Nisqually station. After much negotiation, the US government purchased the rights of the HBC/PSAC south of the international border in 1869. Fort Nisqually was closed the next year. Huggins became an American citizen and filed a preemption claim on the area. The Huggins Homestead was later sold to the DuPont Company in 1906.

The first inhabitants of present-day DuPont, Washington, were Native Americans. They lived here long before the coming of Euro-Americans and developed a sophisticated lifestyle tied to the natural environment and its resources. One key resource was Sequalitchew Creek. Originating in Sequalitchew Lake, the creek flows approximately five miles to Puget Sound. For centuries, Nisqually people resided in a village near the mouth of the creek.

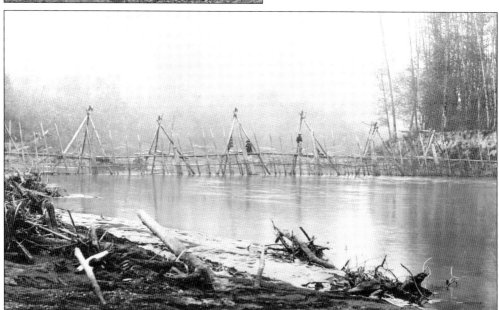

Fish, especially salmon, were an important part of the Native American diet. Fishing methods included fish traps or weirs, hook and line, nets, fish spears, and fish clubs. A fish trap on the Puyallup Indian Reservation owned by Yelm Jim is pictured around 1885. (Courtesy of Washington State Digital Archives.)

Over the ages, many skilled Native American basket makers have lived in the region. One of the greatest was Nancy Jim Parsons. Born of Cowlitz Tribe descent around 1871, she married John Parsons of the Nisqually Tribe. By making baskets, she helped to preserve important aspects of traditional culture. Nancy Jim Parsons died in 1918 and was buried in the Lacey Pioneer Cemetery. (Courtesy of Drew Crooks.)

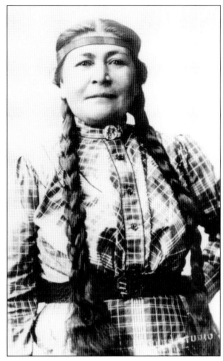

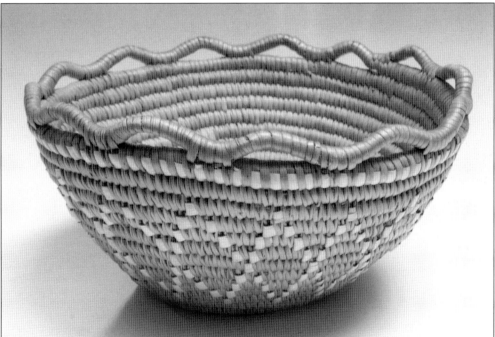

This beautiful basket at the DuPont Historical Museum is attributed to Nancy Jim Parsons. Like other pieces made by the master basket maker, it is done in the Cowlitz/Nisqually style: coiled in structure and decorated with imbricated designs. To make the baskets, she used cedar root, cedar bark, bear grass, wild cherry bark, and horsetail root. Those that survive today form a wonderful cultural legacy.

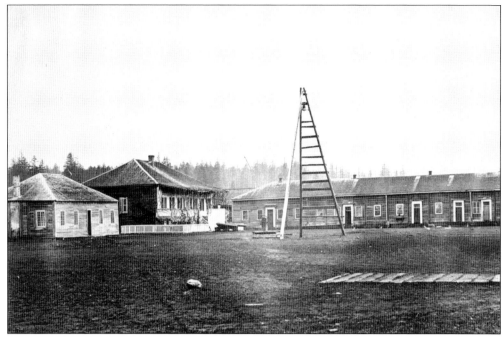

At its height during the 19th century, the Hudson's Bay Company maintained a network of trading posts in northern North America that were involved in fur trading. Fort Vancouver on the Columbia River, seen in this 1860 photograph, oversaw for many years the HBC's posts in the Pacific Northwest. (Courtesy of Washington State Digital Archives.)

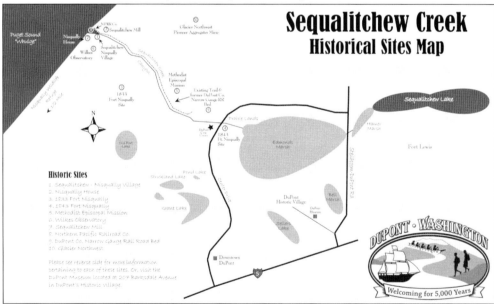

In the mid-19th century, the HBC operated a trading post on land that is now part of DuPont. A temporary post, named Nisqually House, was created in 1833 near Sequalitchew Creek's entrance to Puget Sound. Later, in 1833, the company established a more long-term post inland and called it Fort Nisqually. In 1843, the HBC post, still called Fort Nisqually, was relocated a mile farther inland.

Dr. William Tolmie, seen in this c. 1860 photograph, was the HBC officer in charge of Fort Nisqually's relocation in 1843. He capably commanded the post until 1859, working well with Native American trade partners and strongly defending company rights against incoming American settlers. In addition to being a medical doctor, he actively collected botanical specimens and studied native languages. (Courtesy of Washington State Historical Society.)

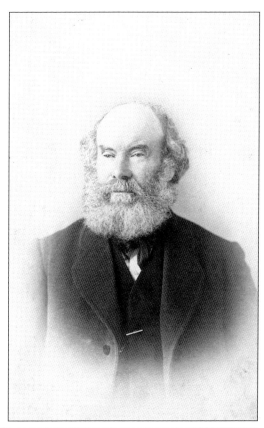

James R. Beattie created this drawing of Fort Nisqually in 1860. By this time, the raising of livestock and crops had overtaken fur trading in importance at the post. HBC farming activities were handled by a company subsidiary, the Puget Sound Agricultural Company. Edward Huggins commanded Fort Nisqually from 1859 until the post's closure in 1870. (Courtesy of Hudson's Bay Company Archives, Provincial Archives of Manitoba.)

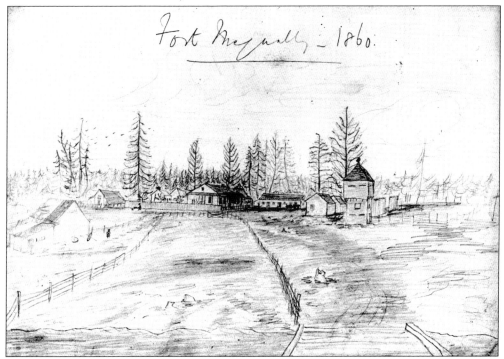

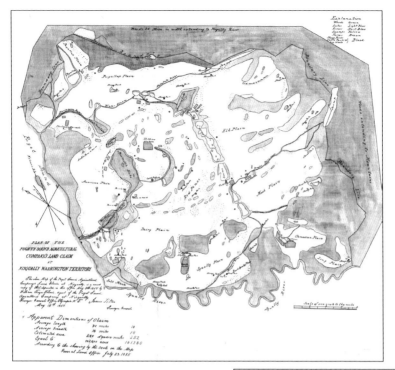

Not all farming was done close to Fort Nisqually. A network of Puget Sound Agricultural Company satellite farms (called outstations) was situated in the region between the Puyallup and Nisqually Rivers. This 1855 map of PSAC claims recorded the location of these farms. Fort Nisqually, at lower left, served as regional headquarters. (Courtesy of Washington State Library.)

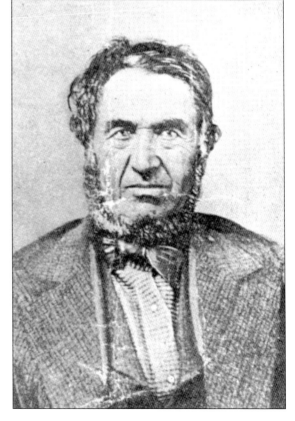

Some PSAC outstations existed south of the Nisqually River in present-day Thurston County. Thomas Linklater, seen here, supervised the Tenalquot Farm near the Deschutes River in central Thurston County. In 1851, he resigned from the company and became an American citizen, taking the old Tenalquot outstation as a donation land claim, which he farmed for many years with his Native American wife, Mary. (Courtesy of Washington State Library.)

The PSAC built a blockhouse at the Tenalquot outstation in the 1840s. Amazingly, the structure survived for almost a century before burning in the 1930s. Tenalquot's name originated from the Native American term *ten al quelth*, which can be translated as "the best yet." Today, the area remains prime agricultural land, especially for grazing cattle. (Courtesy of Drew Crooks.)

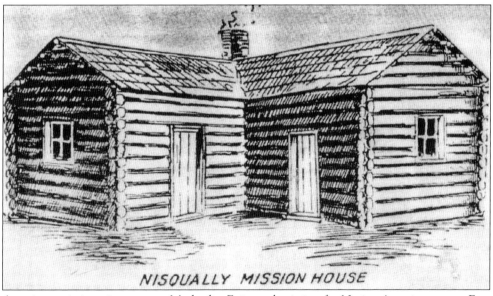

American missionaries set up a Methodist-Episcopal mission for Native Americans near Fort Nisqually in 1839. The next year, the Rev. Dr. John P. Richmond became leader of the enterprise. For several years, Richmond and the other missionaries worked hard on their endeavors but faced many challenges on the frontier. The mission closed in September 1842.

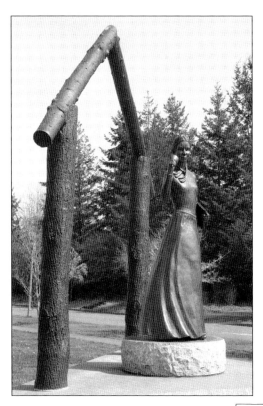

One worker at the Nisqually mission was Chloe Clark, who married William Willson at the mission. She served as a teacher for Native Americans. After the mission closed, Chloe Clark Willson played a leading role in the development of Willamette University in Salem, Oregon. The Chloe Clark Elementary School in DuPont is named after this strong advocate of education, and honors her with the statue seen here.

In the mid-19th century, the United States Exploring Expedition, often called the Wilkes Expedition after its commander, Charles Wilkes, who is portrayed here, circled the world on a voyage of discovery. They visited the Pacific Northwest in 1841 and used the Fort Nisqually area as a base for both maritime and land explorations. A scientific observatory was set up near the trading post. (Courtesy of Library of Congress.)

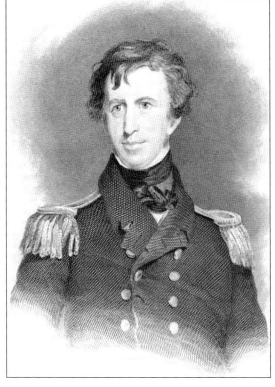

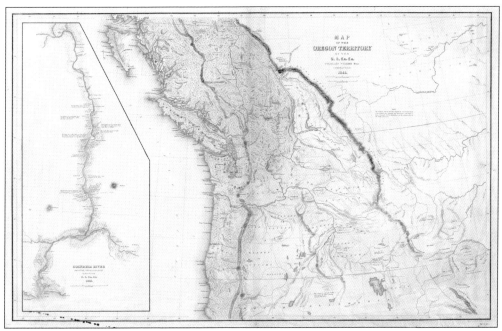

The Wilkes Expedition produced detailed maps and charts, including this map of the Pacific Northwest. Besides mapping, the expedition collected specimens and artifacts and showed the American flag. While near Fort Nisqually, the Wilkes Expedition famously celebrated America's Independence Day. The festivities took place on July 5th, since the Fourth of July that year fell on a Sunday. Americans at the Nisqually Mission participated in the celebration. (Courtesy of Washington State Library.)

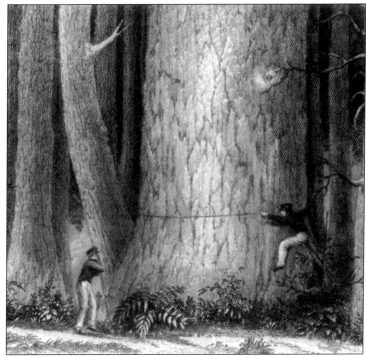

As seen in this illustration from the *Narrative of the United State Exploring Expedition*, members of the Wilkes Expedition were amazed by giant trees in the Pacific Northwest. Professional scientists were part of the voyage. They made studies and collected botanical, zoological, geological, and ethnological specimens that later became an important part of the Smithsonian Institution's holdings. (Courtesy of Library of Congress.)

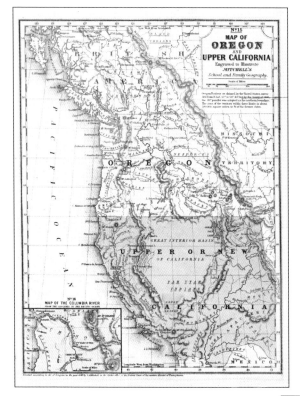

This 1846 map of Oregon and Upper California, created by S. Augustus Mitchell, depicts an undivided Oregon Country, or Pacific Northwest. In 1846, a treaty divided the Oregon region between Great Britain and the United States at 49 degrees north latitude. Fort Nisqually and the surrounding area came under American rule, but the treaty protected the possessory rights of the HBC/PSAC. (Courtesy of Washington State Library.)

American settlers came to the Pacific Northwest in the mid-19th century. Most arrived seeking to own land. Michael T. Simmons (pictured) and George Bush led a party of settlers to South Puget Sound. Simmons founded New Market (later Tumwater) and worked occasionally at Fort Nisqually. Bush, an African American pioneer, was known for his generosity to others. (Courtesy of Washington State Digital Archives.)

This photograph shows Elizabeth Simmons, wife of Michael T. Simmons. The Simmonses had good ties with the HBC/PSAC at Fort Nisqually. Many American settlers did not recognize the rights of the two British corporations that were protected by the 1846 treaty. Some settlers even encroached upon HBC/PSAC land. American pressure did not cease until the US government purchased the HBC/PSAC rights in 1869. (Courtesy of Washington State Digital Archives.)

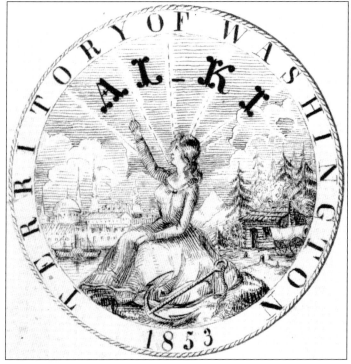

In 1853, the US Congress split off the northern part of Oregon Territory to create Washington Territory. J.K. Duncan, an American Army lieutenant, designed the new territory's official seal. It illustrated the hopes of American settlers to move from "wilderness" pioneer existence (right side) to "civilized" life (left side). Native American and HBC/PSAC concerns were not included. (Courtesy of Washington State Archives.)

US president Franklin Pierce appointed Isaac Stevens as the first governor of Washington Territory in 1853. Stevens was a brilliant and energetic individual but at the same time highly opinionated and easily offended. He strongly supported American settlement of Washington Territory. He also felt little sympathy for Native Americans and HBC/PSAC employees (including those at Fort Nisqually and its outstation farms). (Courtesy of Washington State Digital Archives.)

Native Americans and US government representatives, led by Gov. Isaac Stevens, met in council at Medicine Creek (now McAllister Creek) on the Nisqually Delta in 1854. The resulting treaty arranged for the purchase of Native American lands by the American government. The Treaty Tree, seen here, for many years marked the council site. In 2006, the tree (then a snag) fell during a storm. (Courtesy of Lacey Museum.)

The Medicine Creek Treaty of 1854 seriously affected Fort Nisqually operations, as the trading post depended on Native American workers and customers. Depicted at right is the Nisqually leader Quiemuth, who attended the Medicine Creek Council. For years he had friendly ties with the HBC/PSAC. Quiemuth's name means "strong man" in Lushootseed, the local language. The term described him well. (Courtesy of Washington State Historical Society.)

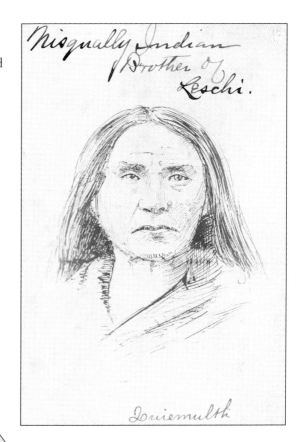

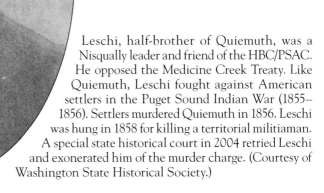

Leschi, half-brother of Quiemuth, was a Nisqually leader and friend of the HBC/PSAC. He opposed the Medicine Creek Treaty. Like Quiemuth, Leschi fought against American settlers in the Puget Sound Indian War (1855–1856). Settlers murdered Quiemuth in 1856. Leschi was hung in 1858 for killing a territorial militiaman. A special state historical court in 2004 retried Leschi and exonerated him of the murder charge. (Courtesy of Washington State Historical Society.)

The Nisqually Tribe survived the Puget Sound Indian War, years of forced assimilation, and losing two-thirds of its reservation when Camp Lewis (now JBLM) was established in 1917. Native American fishing led to the "fish wars" of the mid-20th century when governmental regulations clashed with traditional practices. Fishing rights were finally recognized in federal court decisions. Today, the Nisqually Tribal Center, seen here, represents the strength of the tribe's self-government.

Recently, the Nisqually Tribe has been a growing economic presence in the region. The Nisqually people have also maintained a commitment to preserve their cultural heritage. Part of this commitment is participation in the annual Canoe Journeys that since 1989 have brought native people by canoes to different host tribes. In 2016, the Paddle to Nisqually culminated in a Port of Olympia landing and celebrations on the Nisqually Reservation.

In 1859, Dr. William Tolmie left Fort Nisqually to work for the HBC at Fort Victoria. Edward Huggins, seen here, assumed command of the Nisqually post and its system of farming outstations. After the HBC/PSAC closed operations at Nisqually in 1870, Huggins gained American citizenship and took a preemption claim on the area he had known since first arriving in 1850.

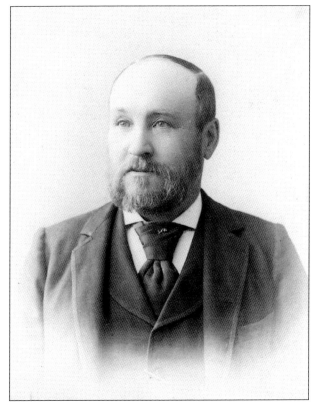

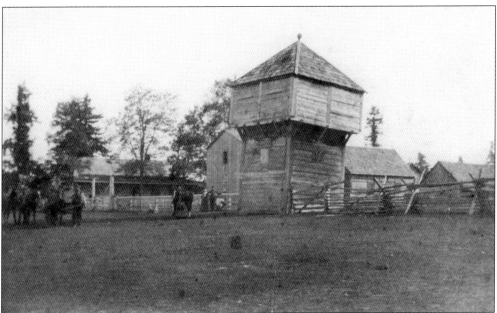

For decades, the Huggins family operated a prosperous farm in the area of Fort Nisqually. This 1884 photograph, taken by Carl August Darmer, shows how the family used the old fort buildings as long as the structures stood. Historians are indebted to Edward Huggins for his extensive writings that provide many details of HBC/PSAC life. (Courtesy of Washington State Digital Archives.)

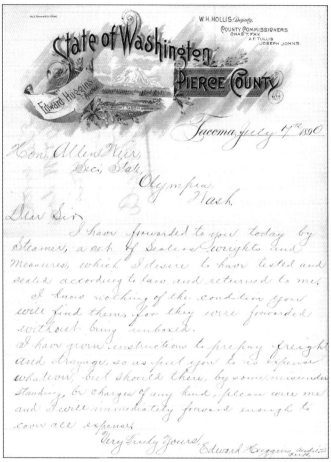

Besides farming, Edward Huggins served three terms as a Pierce County commissioner and one term as Pierce County auditor. Shown here is a letter from his time as auditor. In 1906, Edward and Letitia Huggins sold their large farm to an agent of the E.I. DuPont de Nemours Company. It was the end of one era and the beginning of a new one. (Courtesy of Washington State Archives.)

The DuPont Company constructed an explosives manufacturing plant and a community on the land purchased from the Hugginses. Two HBC/PSAC buildings still remained from Fort Nisqually. These buildings and other local historic sites were not forgotten. This photograph shows historians and Huggins family members at Fort Nisqually in 1921 with the granary at left and the chief factor's house in the background.

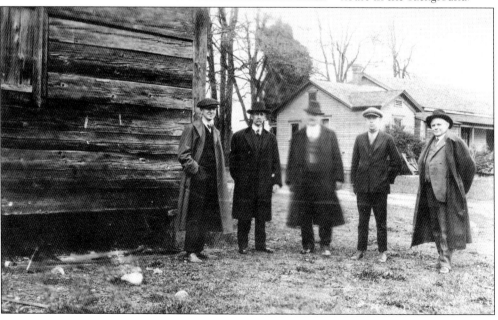

In 1921, the visiting historians and Huggins family members intended to identify spots of great historical significance in the DuPont area so that the DuPont Company could mark them with signs. Here, the visitors are at the site of the Wilkes Observatory, which was used in 1841 by the American explorers for scientific studies and charting.

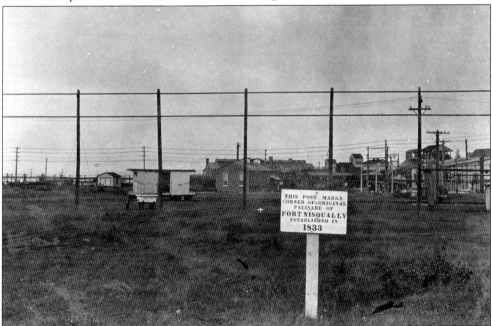

At first, the DuPont Company placed wooden signs at the places in DuPont determined to be of the greatest importance. This photograph shows the sign at the 1833 Fort Nisqually site. In the background are buildings of the explosives plant. In time, the wooden signs were replaced by more permanent metal plaques on concrete stands. In addition, the DuPont Company tried to protect the historical sites from any damage.

Since 1976, when the DuPont Company closed its DuPont plant, people have continued to protect the important historical sites of their community. These places are a source of local pride. This photograph shows visitors touring the 1843 Fort Nisqually site, which is owned by the nonprofit Archaeological Conservancy and is opened to the public on special occasions by the DuPont Historical Society.

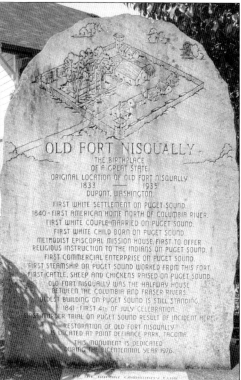

Many residents in DuPont recognize the significance of the area's heritage. Pictured here is a visible reminder of this heritage, a monument next to the DuPont Historical Museum that lists some of the historical firsts associated with Fort Nisqually. HBC/PSAC operations in the 19th century at the trading post greatly affected the historical development of the region.

Two

DuPont Plant

The E.I. DuPont de Nemours Company was founded in 1802 in Wilmington, Delaware. Manufacturing explosives, it grew to have plants spread across the East Coast and Midwest. Attracted by developing markets in the Pacific Northwest and Alaska, the company decided to build a plant on the West Coast. Wanting to be close to major urban centers along Puget Sound and near water and railroad transportation, it chose the sparsely populated site of the former Fort Nisqually.

The DuPont Company purchased nearly five square miles of land, including Edward Huggins's homestead claim. Construction on the plant started September 1, 1906. First housing workers in temporary tar paper homes, DuPont later built a company town, the DuPont Village (now called the Historic Village), a safe mile away from the plant. It began production in September 1909. That year, the company estimated that the facilities had a capacity for 18 million pounds of explosives per year.

The DuPont Powder Works plant manufactured black powder (until 1945) and dynamite. After World War I, it also made pyrotol and sodatol using surplus Army explosives. The company recruited mostly skilled workers from its other plants across the nation for the dangerous work. Many workers stayed for the rest of their careers due to the company's generous pension system and low-cost quality housing.

Ever mindful of safety, buildings were constructed separately from each other and barricaded by earthen works to contain fires and explosions. Workers were required to wear work clothes without metal to reduce spark-causing friction. The company built a small brick hospital on the plant grounds in 1938. Safety improved rapidly with changing technology, and accidents became rarer as the decades passed.

Through much of the 20th century, the DuPont plant produced explosives for military and civilian use. A children's mystery novel was even written about DuPont, *The Powder Dock Mystery* by Reed Fulton, published in 1927. The company closed operations at DuPont in 1976, ending a long era. Over time, the plant had manufactured over one billion pounds of explosives. Now merged with Dow Chemical, DowDuPont is the world's largest chemical manufacturer.

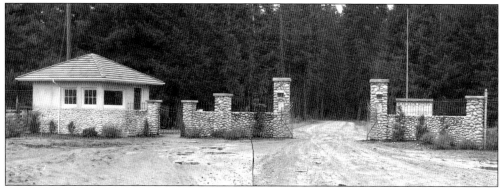

Workers entered the DuPont plant grounds by the main gate. Due to the hazardous nature of the plant's work, access was strictly restricted and a guardhouse sat next to the gate. The gate itself was built of native cobblestone and erected with prize money from records set without a lost-time injury. The rock pillars of the gate were moved to the entrance of the Historic Village after the plant closed.

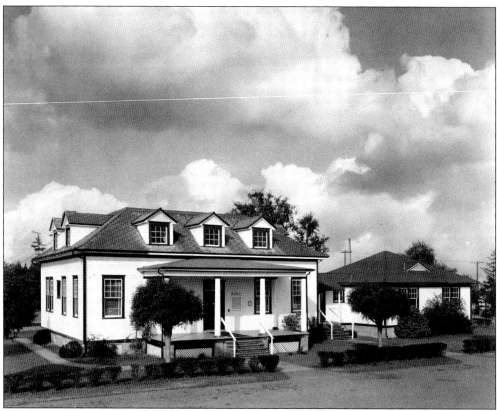

The DuPont Company was headquartered at Wilmington, Delaware, but needed its own administration to run the local DuPont plant. Located in the middle of the plant grounds, the main office building (left) was built in 1907. With production expanding, an annex with four more office rooms (right) was constructed in 1924. William F. Harrington was the plant's first manager (1909–1915) and Irving J. Cox was the first assistant manager (1909–1915).

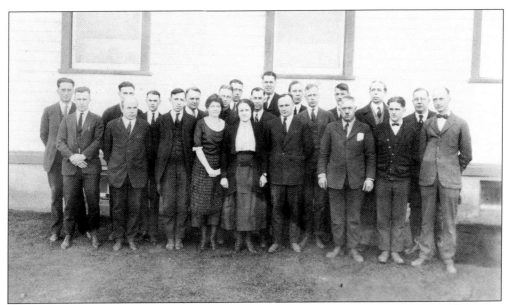

A group of DuPont plant office employees gather outside an administrative building in the 1910s. Construction of the plant began on September 1, 1906, with William Chamberlain as engineer. Work continued until October 1907. A national financial panic suspended construction until the following summer. Production began on September 21, 1909, with a 2,350-pound batch of 40 percent straight nitroglycerine dynamite. Plant capacity for the year was estimated at 18 million pounds.

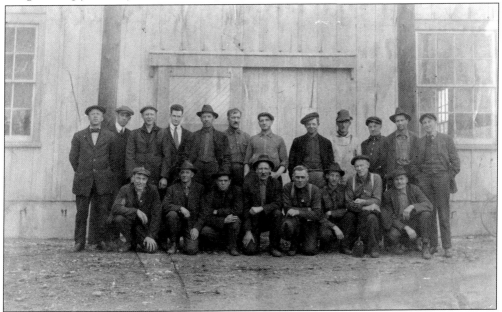

The Acid Department celebrated 730 days without a major accident in 1920. From left to right are (kneeling) Irwin Adams, Charles Nicklason, Arthur Copeland, Gust Ogren, John Bergstrom, Peter Nicklason, Lewis Douglas (killed in a 1922 explosion), and George Kinney; (standing) Richard Madden, Ralph Hammitt, Alfred Grodvig, Elliott Backup, Ben Holm, Edward Armstrong, Philip Kneip, Peter Bolling, Hal Bush, Jacob Koppenhaver, Henry Hammond, and Thomas Anthony (crew superintendent).

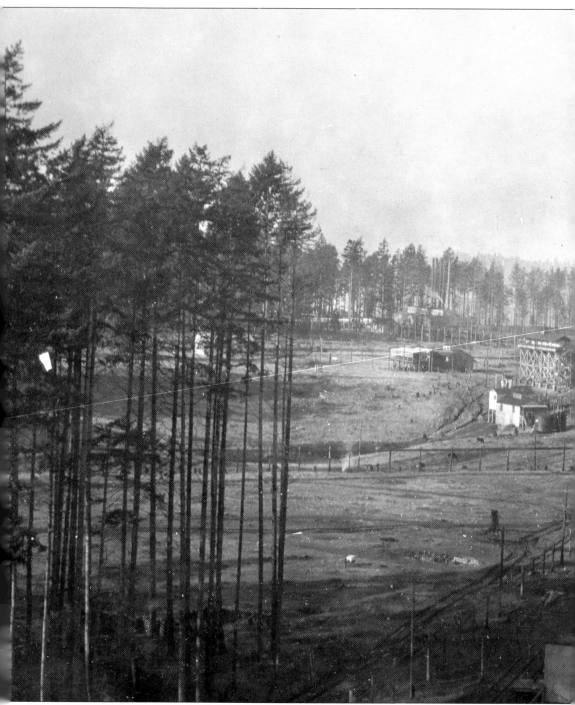

This undated overview of part of the DuPont plant shows shops, the powder house, and the acid area. The plant grounds covered 3,200 acres. The Olympic Mountains and Puget Sound are visible in the distance. To reduce the potential damage of explosions, buildings were spaced far apart. Earthen barricades, visible near some of the buildings on the left, were designed to contain explosions. Vegetation was kept down as brush fires were a serious danger. The plant's

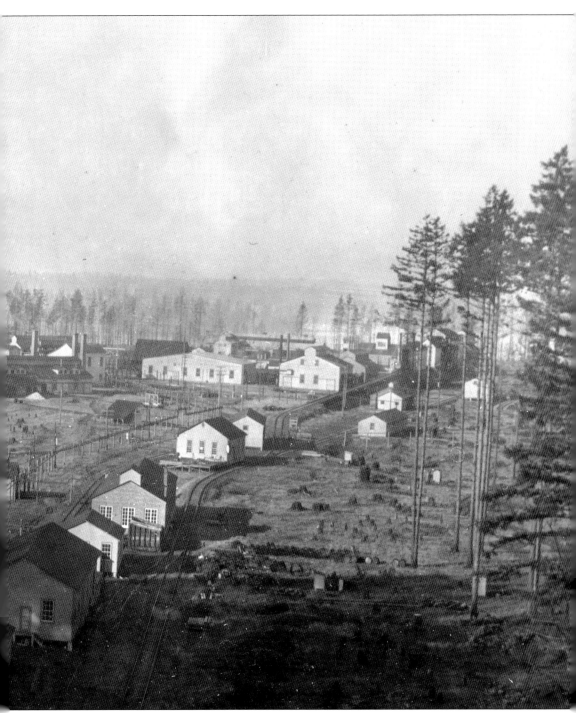
narrow gauge railroad, which transported materials between buildings, is visible at far left and center. Brine lines from the powerhouse, which supplied heat for chemical reactions used to create dynamite ingredients, are visible at center as well. Northwest Landing, a real estate development, is partially located on the former plant grounds.

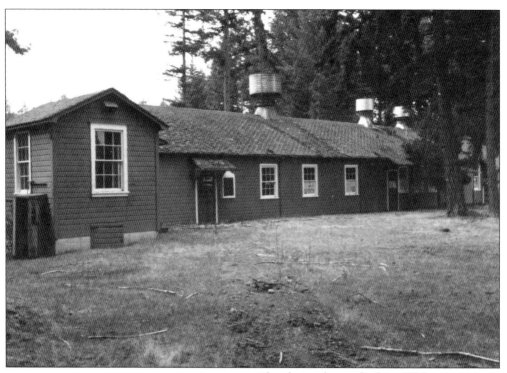

The change house, built in 1936, is seen in this 1985 photograph. Powder workers changed from street clothes to work clothes in this building. The change house also had showers, lockers, a lunchroom, and a lab to test air samples from the powder buildings. Since work clothes picked up hazardous and explosive materials, they were washed at the plant laundry rather than taken home.

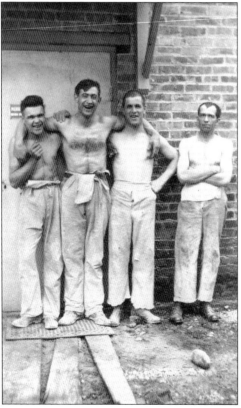

Ed Legacy, Walter Strouss, and two unidentified powder workers pose in front of the change house wearing company-issued clothing. To reduce the risk of sparks, workers wore no metal on the plant grounds, including belt buckles. Shoes were required to have no nails in the soles. To prevent friction-causing material from becoming lodged in clothing and creating sparks, pockets were slit on shirts and overalls had no pockets.

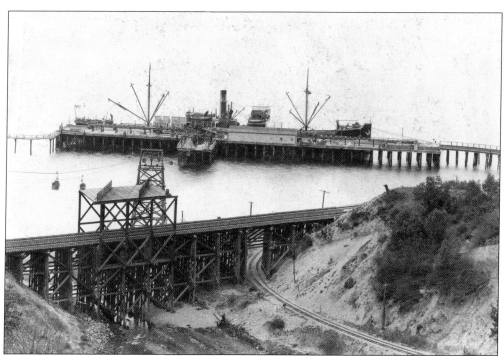

The DuPont Company chose this site partially for its access to Puget Sound, allowing ingredients, equipment, and finished products to be shipped by sea, especially to Alaska. In 1910, the company built a wharf at the mouth of Sequalitchew Creek. The Northern Pacific Railroad (foreground) also transported some of the explosives and brought in supplies. Note the company's narrow-gauge railroad crossing under the Northern Pacific main line.

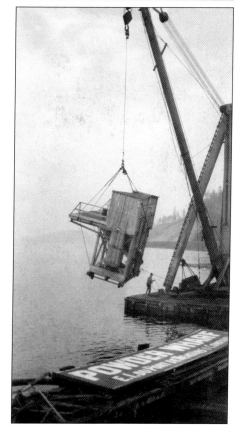

A 50-ton derrick unloads hoppers from a freight ship to the shore on November 17, 1928. The company also shipped out its products by water, usually without incident. However, on August 8, 1928, the launch *LaBlanca* caught fire and exploded while traveling the Tacoma Narrows with a cargo of 15,000 pounds of dynamite and 6,480 pounds of black and sporting powder. The crew beached the boat and escaped without injury.

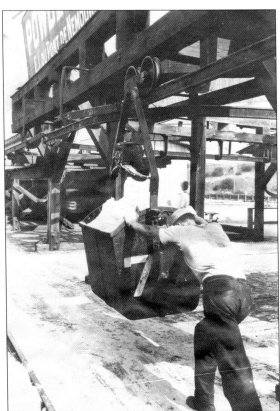

A telpherage system was used to transfer raw materials from the wharf to the DuPont plant. Materials were loaded in buckets suspended by cables and taken 220 feet up the bluff to the dope dry house. The system was powered by an electric motor. Here, ingredients such as sodium nitrate, imported from Chile, were dried before processing. Trains delivered other supplies from the wharf by narrow-gauge railroad.

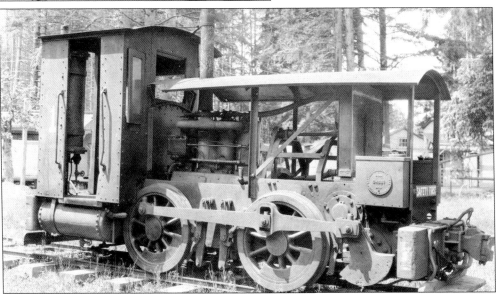

To transport materials around the plant, the company built a 17-mile narrow-gauge railroad. At 36 inches, the track was narrower than standard tracks. Laid in 1906, it was mostly built with 30-pound rail and some 35-pound rail. The company purchased its first engine on July 10, 1910, from Baldwin Locomotive Works. Locomotive No. 1, a seven-ton gasoline engine, cost $3,900. It was scrapped in September 1921.

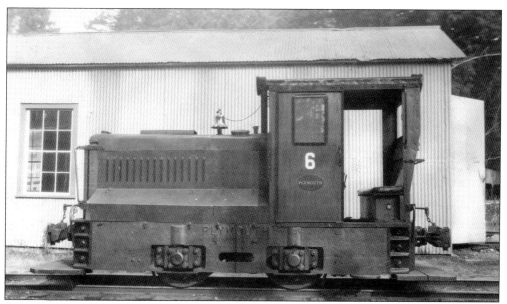

The company purchased two other gasoline-powered engines from Baldwin in 1914 (seven-ton Locomotive No. 2) and 1915 (nine-ton Locomotive No. 3.) In 1930, the company purchased a Plymouth DLC Type 6, eight-ton gasoline locomotive (pictured) from A.H. Cox & Co. in Seattle for $3,415. Two more eight-ton Plymouths were purchased soon afterwards, and a fourth was purchased in 1942. In 1952, the gas engines were replaced by diesel.

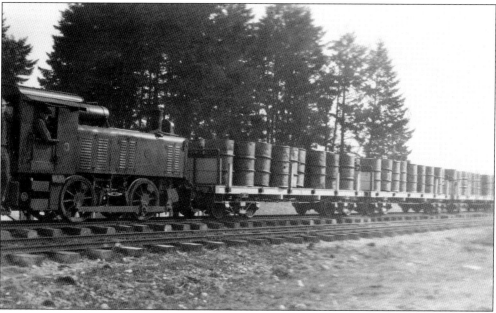

A locomotive pulls hopper cars of processed materials from the dope dry house to the dope house and other buildings on the dynamite "powder line." The railway provided a smooth ride, but to reduce risk of sparks, spark arrestors were installed on the combustion engine's exhaust stacks. Northern Pacific steam locomotives that picked up cars at the plant needed spark arrestors over their smokestack outlets to enter the grounds.

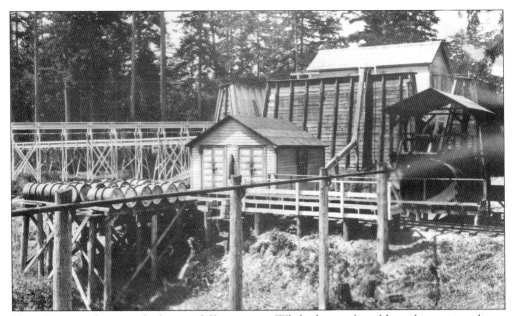

Manufacturing dynamite had many different steps. While the combustible and inert ingredients were being processed in another part of the plant, workers manufactured nitroglycerine in the heavily barricaded and reinforced nitrator house. Nitric acid and glycerin were "nitrated" using steam and air pumped in from the powerhouse via overhead lines (left) to keep precise temperature control, allowing for safe purification and neutralization of the very volatile nitroglycerine.

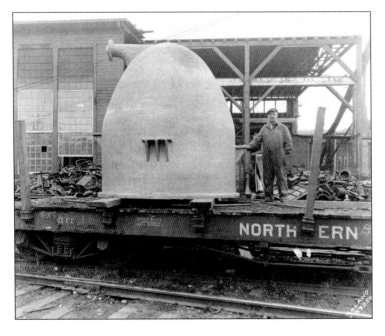

A worker is dwarfed by the DuPont Company's first nitric acid retort atop a train bed. A retort contains the decomposition of sodium nitrate, allowing the final product to drain out of the tube. The DuPont plant had several retorts. This photograph was taken before the plant manufactured its first explosives product on September 1, 1909, a 2,350-pound batch of 40 percent straight nitroglycerine dynamite.

In the dope house, sometimes called the acid mix house, about half a dozen dry ingredients were weighed out and then mixed together. These combined dopes were screened and passed over magnets to remove any residual foreign materials. The dopes were then dumped into hoppers and transferred to the dynamite mix house, where dope powder was mixed with nitroglycerine to form the finished dynamite mixture.

Black powder was "corned" at the black powder corning mill. Fine-grained ingredients were dampened, mixed together, and pressed into cakes. Once dry, these cakes were broken apart and the grains sorted by size to ensure that the final explosive products would blow up evenly. The mill began operating in 1913. The DuPont plant produced black, fuse, sporting, and fireworks powder in addition to dynamite. This photograph was taken in 1924.

Overhead "brine" lines carried steam and air from the powerhouse to the nitrator. This photograph was taken just north of the nitrator. In 1915, the DuPont plant increased capacity by building the No. 3 combined nitrator and separator, No. 3 neutralizing house, an additional jelly cartridge house, a sulfuric acid recovery, and a nitric acid recovery concentrator. Workers also received a 20 percent pay raise. The average was $3.15 a day, the lowest $3.

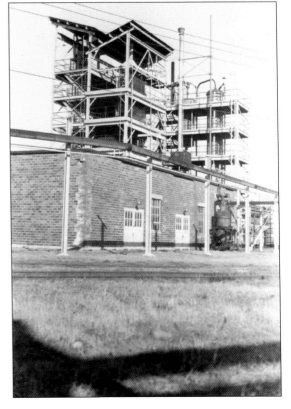

The acid operating plant, known to employees as the AOP, was where weak acid was reboiled and made stronger, a key step in the making of explosives. In March 1916, the company began production of nitrostarch, a type of secondary explosive made from sulfuric and nitric acids. During both world wars, DuPont's products were in great demand by the US military.

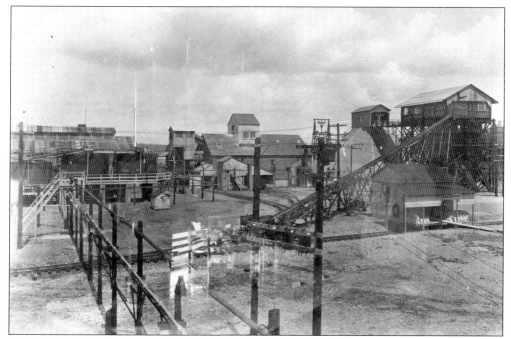

This photograph shows the acid area at the DuPont plant after a rain. The brine lines in the foreground supplied heat to buildings. The narrow-gauge railroad runs through the center of the area. In 1924, the plant started production of pyrotol, an explosive made from surplus smokeless powder and sodium nitrate. In the second month of production, Silas Stewart was burned to death while producing pyrotol.

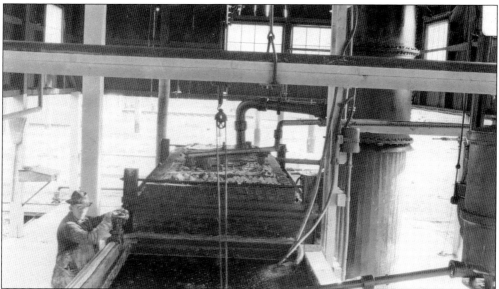

This photograph shows an unidentified worker in front of the sulfuric acid concentrating unit. Completed in March 1925, the building was used to boil and concentrate sulfuric acid for manufacturing explosives. The company also made sodatol from surplus military TNT and nitrate of soda. Total production of pyrotol was 23,170,650 pounds. Reprocessing surplus war supplies took several years. The government assigned Harold F. Warren as inspector for the project.

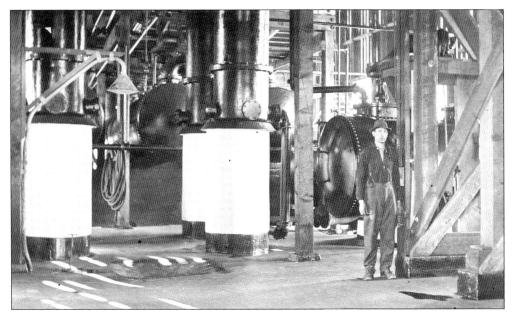

Charles Nicklason stands in the operating unit plant in 1911. "Charlie" worked for the DuPont Company until his retirement in 1943. He was a regular usher at the DuPont Community Presbyterian Church, where he also mowed the lawn. Many workers spent their entire careers at the DuPont plant. In 1926, the company started an insurance allotment plan with workers' regular salary, and a Mutual Benefit Association was organized.

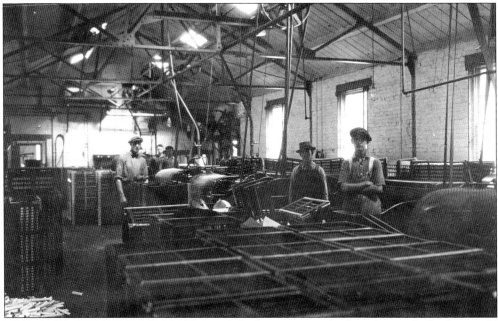

In the shell house plant, employees fabricated the heavy paper cylinder tubes, or shells, that would contain finished dynamite. Machines cut and rolled the paper into cylinders, crimped them closed at one end, and put them through a spraying tunnel that coated them with paraffin wax to protect the dynamite from moisture. Finished shells were stored in the building until needed for filling in the gelatin dynamite auger or hall machine house.

Crates of finished dynamite were loaded in powder cars on the company's narrow-gauge railroad. Finished dynamite was delivered to boats waiting at the wharf and to the Northern Pacific Railroad stop on the plant grounds. Transporting dynamite was dangerous, and "safety first" is duly marked on this powder car in 1923. The crates display the company logo. Much DuPont dynamite was destined for construction and mining, especially in Alaska.

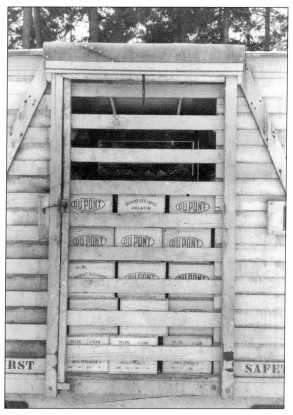

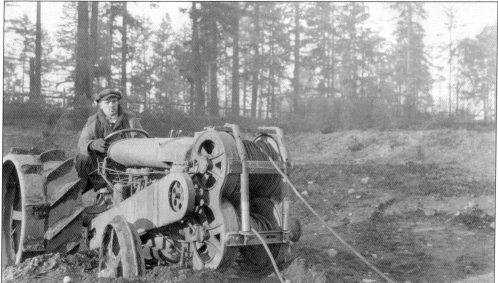

A DuPont plant worker uses a combination Fordson tractor and Hyster to fill earthen barricades for the new No. 3 nitroglycerine house in January 1926. The company was continuously erecting new buildings and fixing old ones, as explosives technology improved over the years. Also in 1926, the company rebuilt the wharf. On December 13, the company celebrated a two-year safety record with a party at Ingleside Gardens Resort.

The company's powerhouse, which generated electricity for the plant and village, was built below the bluff. In 1926, its wooden flume was replaced by metal. Wooden water pipes in the plant and village were also replaced. A test on December 11, 1926, washed out the surface tank, sending 1,500 yards of gravel downhill and into the powerhouse (left) and spilling out the front door. No one was injured.

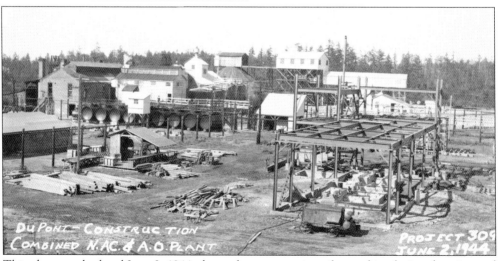

This photograph, dated June 2, 1944, shows the construction of a combined nitroglycerine and acid operating plant. The DuPont plant began making smokeless powder on January 20, 1928. It stopped producing black powder on May 16, 1945. The Great Depression hit the company hard. In 1931, the smokeless powder line was dismantled, and on November 1, the plant reduced operations to five days a week and cut salaries by 10 percent.

Several DuPont plant buildings exploded over the early years of operation. Explosions occurred in 1909, 1910, 1916, 1922, 1924, 1926, 1930, 1935, 1936, 1938, and 1947. This photograph shows the black powder corning mill burning after an explosion on August 11, 1924. Burning powder from the explosion started grass fires that were soon contained. The incident caused no casualties. Over the years, 16 workers lost their lives in accidents at the plant.

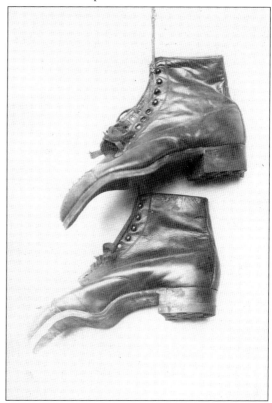

Accidents were a constant danger at the DuPont plant. On January 8, 1923, Frank Wing was caught in machinery at the soda dry house. He was spun around a shaft, and his feet struck a brick wall. His shoes, photographed after the accident, show extensive damage. Wing survived but was laid up for several months. The accident broke the Mechanical Division's record of 406 days without accident.

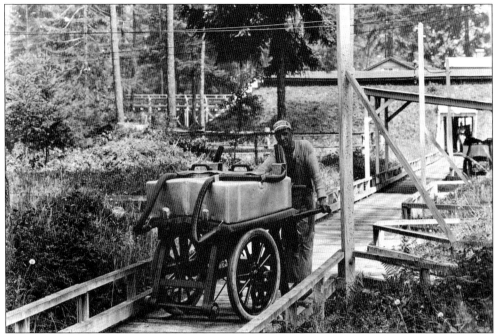

Moving finished nitroglycerine to be mixed into dynamite was among the most dangerous steps of producing explosives at the DuPont plant. Batches were transported by a "Little Eva" (Jess Beyers) on a small rubber-wheeled cart ("Angel Buggy") over a long wooden walkway called the "Angel Walk." Any jolt or misstep could send the worker heavenward. Later technology created safer equipment closer to the mixing site, but this step remained dangerous.

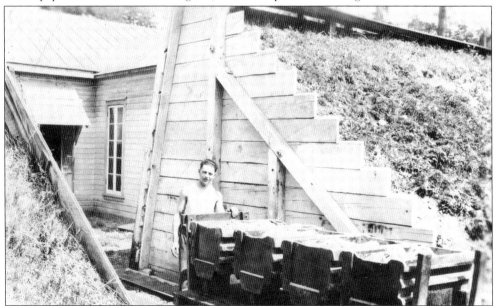

This man stands by a barricade at a building on the DuPont plant. Wooden barricades filled with dirt were put around buildings to contain fires and explosions. Openings in the barricades allowed a quick exit. Only a handful of workers were in a building at a time. Workers, sometimes teenagers hired for the summer, cut brush on the grounds to reduce the risk of brush fires.

Besides the large barricade, just visible to the left of this building, a slide is next to the door on the second story. In case of fire or explosion, workers could escape faster with the slide than using the stairs. George Hutkoi saved the lives of two men working downstairs when he jumped the stairs to warn them to leave before an explosion.

To reduce risk of fire caused by lawn mowers, the company kept cows and deer to crop the grass. At one point, 70 deer and 50 head of cattle freely roamed the plant grounds and the wooded area between the village and the plant. Many workers loved the animals and their antics. This mother deer and her two fawns are being fed by an office worker at the plant.

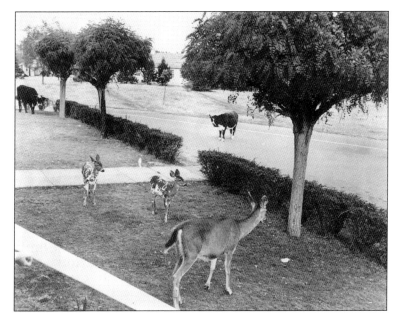

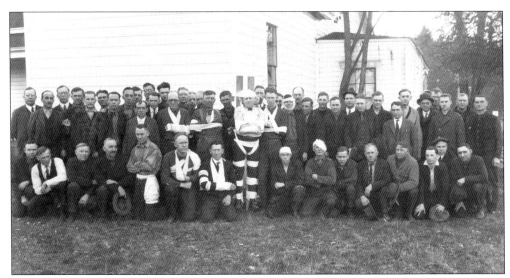

DuPont workers were taught first aid in order to increase workplace safety. In March 1924, John G. Schoning (possibly the man in a white shirt standing at center), from the federal Bureau of Mines, gave lessons to company employees. These workers are showing off their bandaging techniques. In the 1920s, assistant plant manager Phil Cushing led an award-winning Boy Scout first aid team.

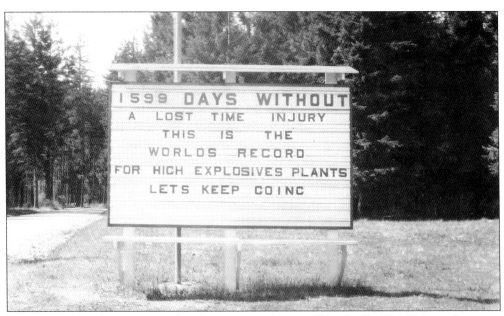

Working with explosives meant that the tiniest mishap could be deadly. The DuPont Company thus urged workers to maintain constant vigilance. This sign near the DuPont plant gate reminds workers that when the photograph was taken on April 30, 1930, a total of 1,599 days had passed without a time-lost injury. The sign proclaims it as a world record for a high explosives plant and encourages employees to continue being careful.

When the plant began operations, first aid was handled by the timekeeper in the main office and later by the chief chemist in the acid laboratory. In the 1920s, Dr. John Walker briefly operated a small office and dispensary near the carpenter's shop on the plant grounds. To provide better health care, the company built a modern one-bed hospital next to the main office in 1938 and hired a full-time nurse.

Dr. Clement Laws was the plant's first resident doctor. Hired in 1909, he treated workers and residents through the company's medical plan. The company aided his practice by supplying drugs, bandages, and an office at the DuPont Hotel. Medications were free to workers. Serious cases went to Tacoma or the State Hospital at Fort Steilacoom. In 1913, Laws started a private practice in Tacoma and was replaced by Dr. Walker.

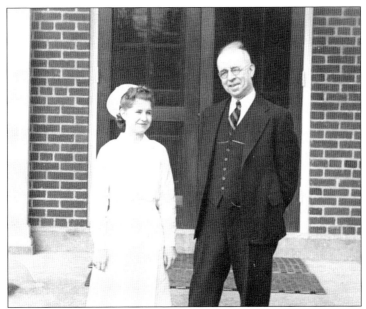

Plant doctor John A. Walker and plant nurse Grace McDaniels stand outside the Medical Building in 1939. Walker served as plant doctor at DuPont from 1913 until his 1941 retirement. When Walker first arrived, his office was two rooms in the DuPont Hotel. He provided most medical care for workers and their families, though he called for assistance from doctors in Tacoma to provide anesthesia and major surgery.

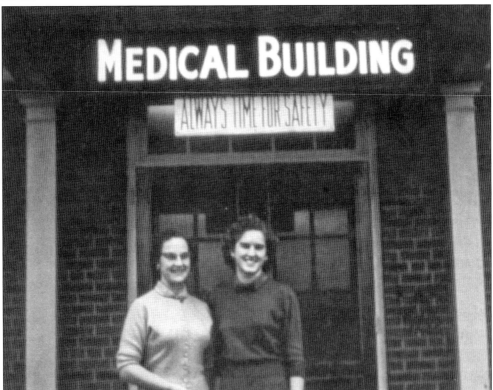

Company secretaries Iona Karan and Barbara Jensen Wyant stand in front of the Medical Building below the company slogan: "Always Time for Safety." Besides caring for the sick and injured, the company tried to reduce accidents by monitoring employee health. For example, men working with nitroglycerine were monitored for changes in their blood pressure; if it became dangerously high, they were moved to other areas of the plant.

Nurse Olga O'Neil is trying out the X-ray machine on secretary Barbara Jensen Wyant inside the Medical Building in 1959. Both O'Neil and Wyant were long-serving employees of the company. O'Neil worked as the plant nurse from 1941 until she married Dr. Bernard Ootkin in 1966 and moved to Lakewood. The company doctor also had an office at 400 Barksdale Avenue after the hotel closed. It later became the superintendent's hiring hall.

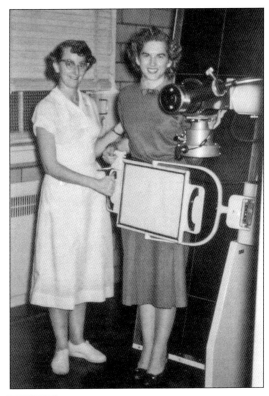

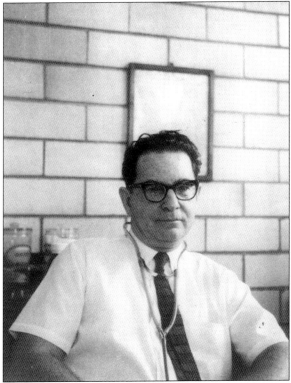

The son of Russian immigrants, Bernard Nathaniel Ootkin (seen here in 1971), inspired by his nurse mother, became a physician. He began work for the DuPont Company in 1941 and continued until 1966. Dr. Ootkin had an office in the village as well as at the plant hospital. His village office initially shared space with Pacific Northwest Bell until the telephone company built its own facilities across from Lonnie's Service Station.

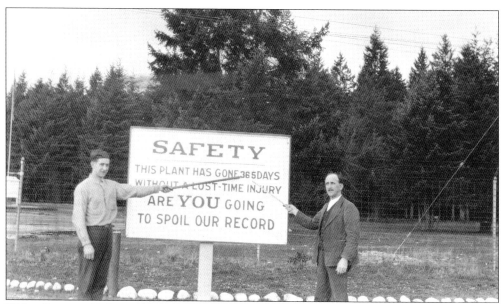

Walter Strous and Julian Fisher point to a sign near the plant fence reminding workers that the plant has gone 365 days without a lost-time injury. The company continually worked to improve safety. For example, the 1.3-mile segment of track that went to the wharf was initially a gravity-fed system, pulled uphill by horses. After two men were killed in an accident, it was replaced with a new system.

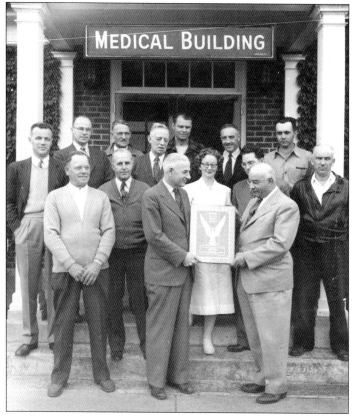

On December 9, 1951, the company celebrated a four-year safety record that earned it a National Safety Council Award. Manager Frank E. Jacquot (right) and assistant manager George W. Collins accept the award as nurse Olga O'Neil and Dr. Ootkin (to her left) look on. The company celebrated several safety records during its years at DuPont, and 1947 saw the last fatal accident at the plant.

The Depression hit DuPont hard. In January 1932, the plant closed, the first time since opening, before adopting a three- to four-day work week later that month. Pay was thrice cut by 10 percent in 1932 and the plant placed on a six-hour day. World War II changed the company's fortunes. Here, plant manager Frank Beers (standing) and assistant manager George Collins accept the Army-Navy "Big E" flag at a 1943 ceremony.

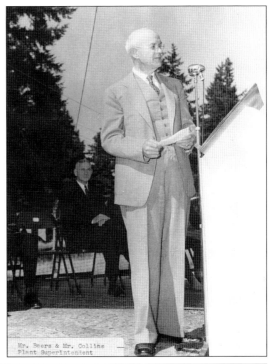

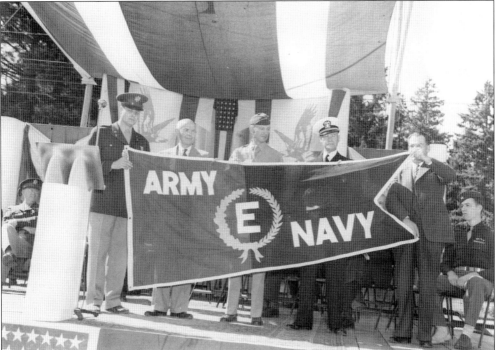

Each year from 1941 to 1945, the DuPont plant received the Army-Navy "Big E" award, which rewarded individual plants for their excellence in war production. The award carried with it the right for employees to all wear "E" pins and to fly the "E" flag above the plant. In 1943, in a widely attended ceremony seen here, a color guard from Fort Lewis raised the flag above the plant.

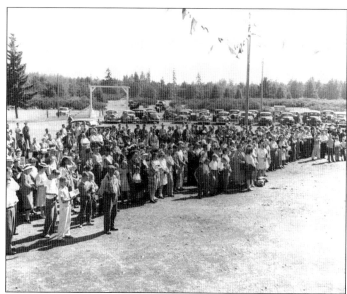

A large crowd gathered to see the 1943 presentation of the "Big E" flag. "I am confident," wrote Undersecretary of War Robert P. Patterson to the plant in 1943, "that your outstanding record will bring victory nearer by inspiring others to similar high achievement." The plant continued to prosper after the war. In 1959, the 50th anniversary of operations, 172 people worked there.

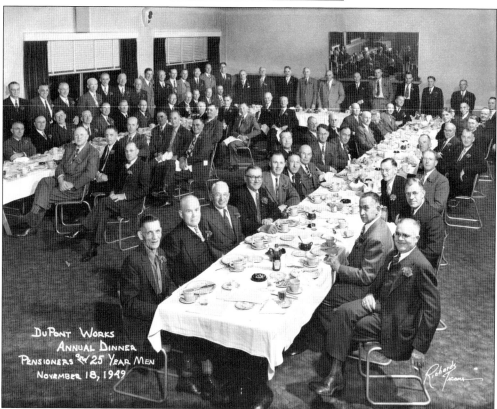

This annual dinner for DuPont workers was held November 18, 1949, at the Towers in Tacoma. The gathering honored pensioners and longtime employees. Many workers remained in DuPont after the plant closed in 1976, retaining fond memories of the company. Donald L. Meyer, an employee from 1950 to 1974, when interviewed in 1999 described it as "a very special and unusual occupation that I was privileged to be part of."

Three

COMPANY TOWN

To house the new dynamite manufacturing plant's employees and their families, the DuPont Company created a small village. With over 100 homes, several businesses, a church, and a school, the new community, named DuPont after its founding company, provided for most of the needs of its employees.

DuPont was a company town, meaning that the DuPont Company owned and maintained all land and buildings, renting them to employees. Businesses, however, were independently operated. All residents of the town worked for the company, were relatives of employees, or had jobs at support facilities. Many workers spent their entire careers at DuPont and retired there on company pensions.

DuPont's employees came from all across the country and world. The 1910 federal census for the village reveals that many workers originated from Sweden, Norway, England, Italy, and Germany or were second-generation immigrants. Others came from the Midwest and East Coast, transferring from various DuPont Company facilities.

In 1912, the DuPont Village incorporated as a town with George Shepherd elected as the first mayor. Council meetings were held at the DuPont Clubhouse. The town government granted a liquor license to the clubhouse, impounded stray cattle, and provided police. Called the town constable or town marshal, Frank Hooker was the community's first law officer. After he quit, Julian F. Fisher held the position for many years. The town voted to disincorporate in 1926. They had incorporated in order to grant a liquor license to the clubhouse, but the company still ran the town. Now with Prohibition in effect, many viewed incorporation as unnecessary.

Construction of Camp Lewis in 1917 greatly influenced the village. Students from the fort attended DuPont schools, and the Johnson Brothers Store was a major supplier for fort families until a new commissary was built in 1959.

DuPont voted to reincorporate as a city in 1951, and the company sold the village's houses to their occupants. The company remained very involved in the community. Its manufacturing plant closed in the 1970s. Today, the DuPont Company era lives on in exhibits at the DuPont Historical Museum.

To house workers constructing the plant, a village of about 50 tar paper homes and a cookhouse were built near the 1843 Fort Nisqually site. Nicknamed "Old Town," the buildings served as temporary quarters into the 1920s. These girls are celebrating a birthday party in Old Town in 1916 or 1917. Those identified are Dorothy Baley (upper left), Virginia Holland (second from right), and Betty Wiley (lower left).

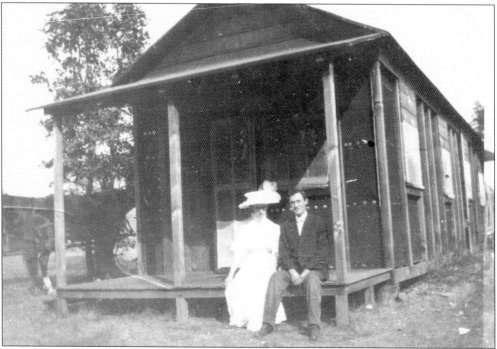

A number of the workers soon sent for their families to join them in Old Town. Glenn and Lizzie Fisher pose outside their tar paper home. Glenn was the son of Alfred Fisher and worked with his father at the Fisher Store in DuPont. Tar paper homes were simple; blankets and newspapers were used to insulate and decorate the plain tar paper–covered boards.

Joseph Cookler and Irene Jones had the first wedding in DuPont. Irene ran the boardinghouse for the plant's construction crew, and Joseph was a plumber/steamfitter who had transferred from Washburn, Wisconsin. Romance blossomed, and the couple's wedding in summer 1907 was widely attended. Living in one of the first tar paper homes, Joseph worked for the company for many years. They raised three children, including Irene's daughter from a previous marriage.

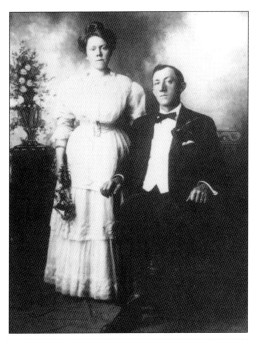

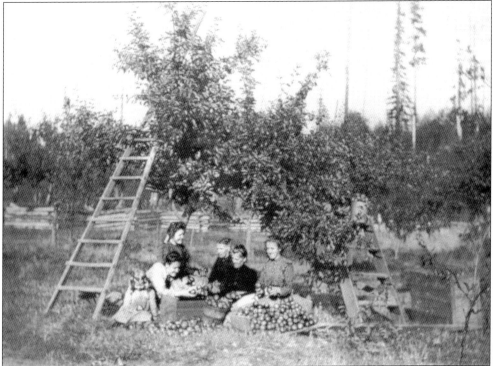

These Old Town residents are enjoying picking apples around 1910, though one child seems to be eating apples more than picking them! Located behind the 1843 Fort Nisqually site, the Hudson's Bay Company planted an orchard near Edmond Marsh. It was continued and expanded by homesteader and former HBC employee Edward Huggins. A protected site, the orchard still produces apples, pears, and plums. It has been designated an Heirloom Orchard.

The DuPont Company began constructing a village for workers and their families a mile away from the plant site, far from any danger of explosion. Hiring carpenter Arthur M. Semple of Tacoma as head of construction, the company began building the village in 1909. Streets were laid out and gas, water, and sewers were installed. Electricity was supplied by the company dam on Sequalitchew Creek, which also powered the plant.

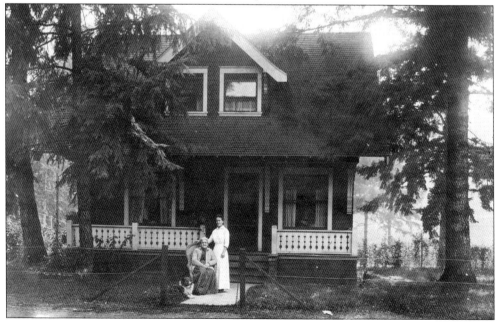

The village expanded steadily into the 1910s. Between 1909 and 1910, fifty-eight new homes were built in addition to businesses and the homes of the managers. New houses were added in 1912 (six), 1915 (six), and 1916 (twenty-three). This 1916 postcard sent to relatives in Lafayette, South Dakota, shows Mary Millie and "Grandma" Laeate next to their new house.

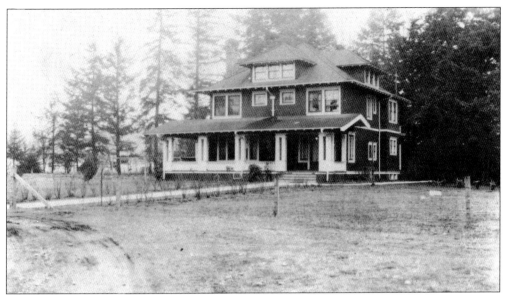

Among the first buildings constructed in the village were stately manager's and assistant manager's residences along Barksdale Avenue near the entrance to the village. Large houses with spacious grounds, the manager's house (above) boasted 15 rooms, and the assistant manager had 10 rooms. Their rose gardens were tended by company gardeners. Their first residents were the families of William F. Harrington (manager, 1909–1915) and Irving J. Cox (assistant manager, 1909–1915).

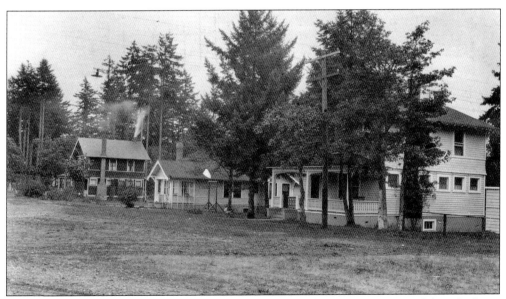

In the 1920s, the DuPont Company collected pictures to show company town life in DuPont. This photograph shows homes along Brandywine Avenue, named after the Brandywine River in Delaware. In 1802, the company built its first factory along the Brandywine River's banks near Wilmington, which remains the corporation's headquarters. The majority of DuPont Powder Works plant managers lived along this street, earning it the nickname "Silk Stocking Row."

DuPont residents have always had a sense of humor. Here, a group of young clowns spell out the word "DuPont" in a field. DuPont is the only DuPont company town to bear the organization's name. The years from the 1890s to the 1920s were a period of rapid expansion of the DuPont Company around the country, which is reflected in the street names of DuPont Village.

With commuting impracticable, all residents of the village were company employees or their families. The company owned and maintained all houses in the village, renting them to employees. Businesses were independently run. This 1920s photograph shows Betty Wiley (left) and Verna Trimble in front of the Johnson Brothers Store.

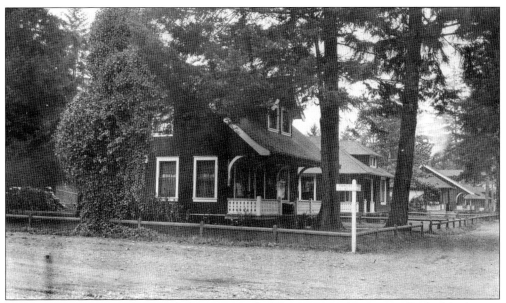

This company publicity photograph shows 300 Barksdale Avenue at the corner of Barksdale Avenue and Forcite Street. Barksdale Avenue was the village's main street, quite appropriate because many of the earliest workers transferred from DuPont's Barksdale plant in Washburn, Wisconsin (built 1904). DuPont's businesses and Presbyterian church all line this road. Forcite Street is named for the Forcite Powder Company, a corporation bought out by the DuPont Company by 1902.

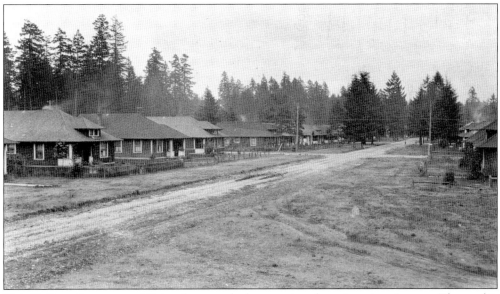

This DuPont Company publicity photograph shows a view down Louviers Avenue. The road is named for the company's facility in Louviers, Colorado. A company town created in 1906, Louviers was originally named for the ancestral village of the DuPont family in Normandy, France. Streets in DuPont remained unpaved until the 1920s, muddy in the winter and dusty in the summer. Sidewalks were added in the village in 1923.

In 1924, a group of children volunteered to fight a grass fire. Service supervisor G.L. Knots organized them into DuPont Fire Company No. 11. It was recognized as the youngest officially listed fire department in the United States. Members were between the ages of 8 to 12 and included, from left to right, Alan Ogren, Ivan Manley, Howard Troupe, Horace Smith, James Hull, Irving Cox, Eugene Rearden, Bryan "Bill" Baldwin, and Ray Grant.

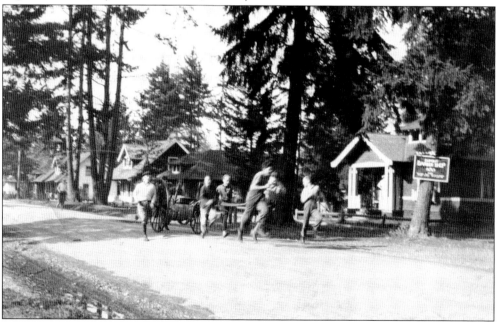

Fire Company No. 11 practiced regularly, maintained the hose carts, and inspected fire conditions. Four sheds were spread strategically around the village, each with a two-wheeled cart. With most men in town working all day at the DuPont plant, these children provided important fire protection for the community. The last remaining hose cart is on display outside the current fire station at 1780 Civic Drive.

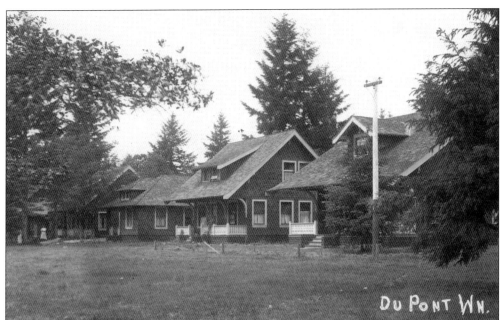

This postcard from Frances McArthur shows a row of houses in DuPont. Originally, houses were painted shades of yellow, white, and gray. Built in Craftsman bungalow style, each home had two to five bedrooms, a kitchen, joint living/dining room, bathroom, front porch, back laundry porch, and an unfinished attic. The size of houses (and the company status of the renters) decreased the farther they were from the village's entrance.

Alan Ogren sits in front of his home (305 Barksdale Avenue) on his paper route in 1924. Ogren; his parents, George and Martha; and his sister Fern were among the first families in DuPont. In 1952, after 46 years of service, George was the 6,500th employee to retire on the DuPont Company's 1904 pension plan. Village boys later sold regional newspapers at Fort Lewis.

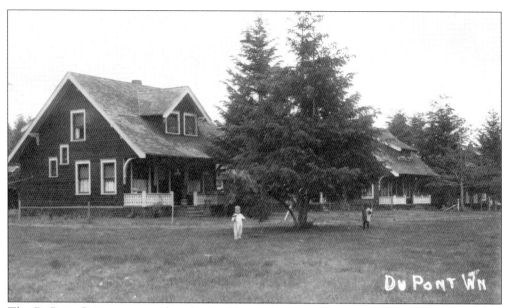

The DuPont Company owned and rented houses in the village to workers for relatively low prices. Many workers had large families, and the town was full of children, exuding an optimistic atmosphere. A newspaper article from the mid-1910s by Berta Snow Adams described the town: "Where Men Don't Smoke or Swear, Where There Are No Unpainted Shacks, Where Flowers Bloom In Profusion And Young Bachelors Always Dress For Dinner."

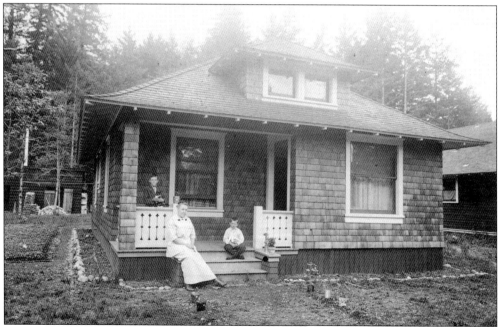

This postcard shows the Ledlie family on their front porch. Recruited from California, Edward Moran Ledlie was among DuPont's first workers. He married Marguerite Legacy in 1913. The couple and their children (James, William, and Margaret) lived at 505 Louviers Avenue. One of the boys in the photograph is holding a cat. Some villagers also kept chickens in the early years.

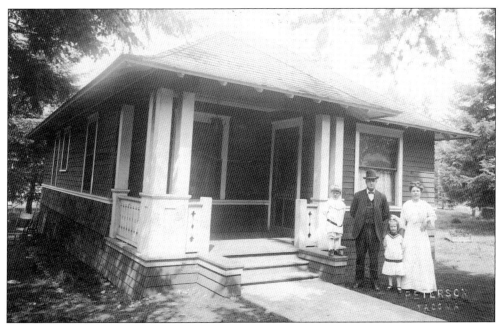

The Cox family gathers outside their 411 Barksdale Avenue home for this picture postcard. Howard and Sophia Cox are shown with their children Margaurette and Irving in the late 1910s. They later had two other children, Myra and Charlie. Today, 104 historic homes remain in DuPont Village, which was made a National Historic District in 1987. Over 30 new buildings have been constructed inside the district since 1976.

Frank and Annie Hooker; Frank's mother, Emma Hooker; and friend Bob Schwartz gather on the front porch of a DuPont home. Frank was the first town constable. With the construction of Camp Lewis, the company purchased six houses that were on the new military post and relocated them to the village in November 1917. Other residents rented out rooms to soldiers and their families.

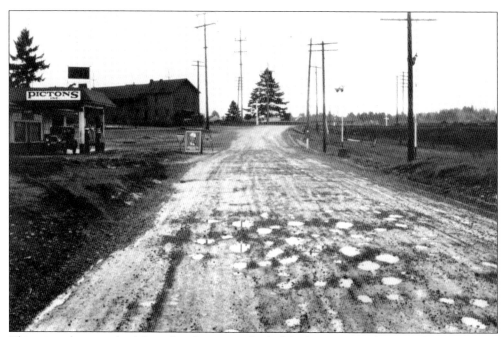

This rainy photograph of the railroad station at Barksdale Avenue was taken on February 4, 1930. It shows the avenue's intersection with Clark Road and Pacific Highway. Note what a good rain can do to a dirt road. Picton's Garage is to the left, with the railroad station behind it. DuPont saw much train traffic to Fort Lewis. The DuPont Company also received supplies and shipped dynamite by rail.

In spring 1931, the road from the Pacific Highway through DuPont to the main gate of the plant was paved. This "after" photograph shows the road through Bob's Hollow. It was named for "Indian Bob," a Native American who worked at Fort Nisqually. A long-term and popular employee, he was murdered by territorial militia while chopping wood for the HBC at the Hollow during the Puget Sound Indian War.

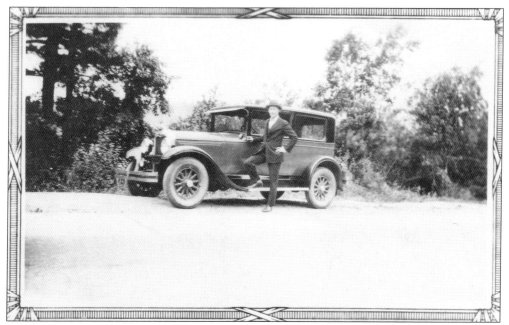

George Johnson shows off his new Oakland car in 1928. Johnson was raised in DuPont and worked for a while with two of his brothers at the Johnson Brothers Store. By this time, most DuPont workers owned their own cars, though traffic in the village was light except when workers went to and from the plant. Workers had formerly often traveled to the plant by bicycle.

In 1929, DuPont spent 22 days below freezing, as attested to by this snowy January photograph. Like that winter, the Great Depression would hit the community hard. Some company employees were laid off, others had salaries and hours reduced. The company offered six vacant houses to employees for $20 to $40 if they agreed to move them out of the village to live in. Some were relocated to Tillicum.

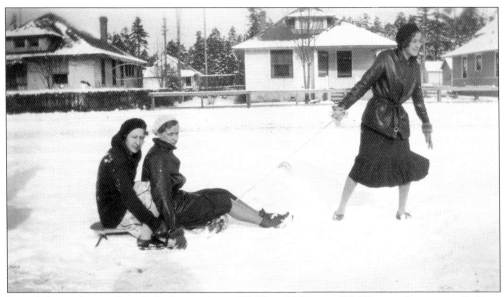

From left to right, residents Lola Gaino, Anne Wolff, and Margaret Wolff enjoy the snow in DuPont in the 1930s. During the Depression, a hobo camp developed along the Northern Pacific Railroad tracks between the water tower and a short-lived Civilian Conservation Corps camp (1941). The hobos often did small jobs like cutting wood and mowing lawns for meals. The looming war in Europe revived company fortunes and community prosperity.

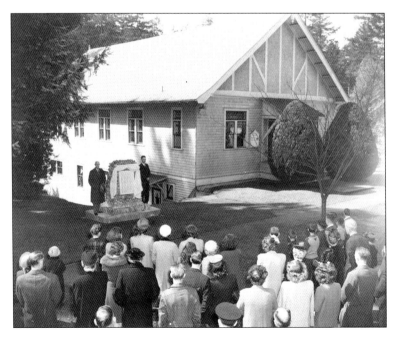

On Easter Sunday, April 1, 1945, the DuPont church dedicated a monument listing the names of 63 men and 5 women from the community who served in World War II. The wooden sign eventually deteriorated. The DuPont Lions Club replaced it with a sheet of paper under glass. The DuPont Historical Museum has the original sign on display.

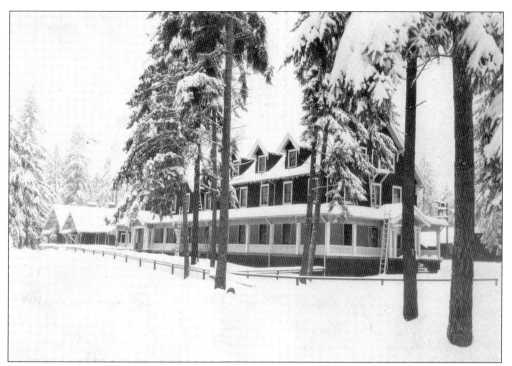

The DuPont Hotel was blanketed by 18 inches of snow on February 14, 1923. The clubhouse is to the left of the building. Located on Barksdale Avenue between Hopewell and Penniman Streets, the hotel opened in 1909 with Estell Foster as manager. The 41-room hotel housed unmarried male workers, who formed the bulk of unskilled laborers at the plant. In the mid-1910s, about 125 lived at the hotel, sharing rooms.

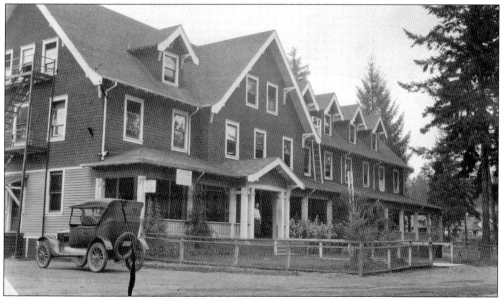

Soldiers sometimes boarded at the DuPont Hotel during World War I. By the 1920s, however, demand for boardinghouses decreased as taking the train and cars made commuting easier. In 1930, the hotel's furnishings were donated to Goodwill and the building demolished.

Among the first buildings in DuPont were two general merchandise/grocery stores, built in 1909. The Fisher Store (303 Barskdale Avenue) was run with two of his sons. The larger Fisher Store changed hands several times and was later operated by the Henderson brothers of American Lake, and lastly by Ernest Pamment. The other general store (211 Barskdale Avenue, seen here) was first leased to Frank A. Downing for a short time.

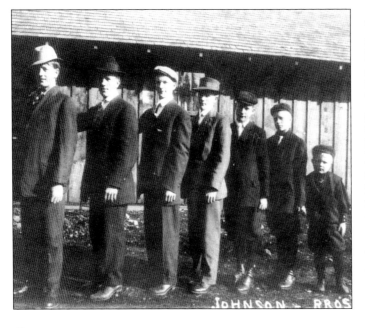

The Downing Store was renamed the Howard Mercantile Company and operated by siblings Carl and Eva Holmes. They sold groceries and general merchandise. G.B. Skewis bought the business in 1914 or 1915. In 1920, brothers Henning and Gunnar Johnson purchased the store. Their father, John Johnson, transferred from Washburn in 1906. John and Hannah Johnson had nine children. From left to right are brothers Herman, John, Elwin, Henning, Gunnar, George, and Raymond.

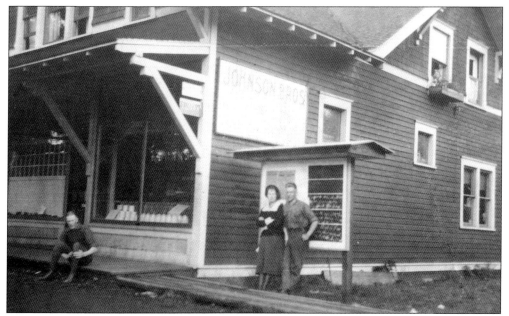

Around 1924, Henning and Gunnar Johnson closed the store at 211 Barskdale Avenue and moved into the former Fisher Store, selling groceries and general merchandise and operating the village post office. The store was enlarged in 1952. Gunnar died in 1955, and two years later, the business was sold to George Hanson. In 1966, it was owned and operated by Mr. and Mrs. Gordon Kersey, who added a lunchroom.

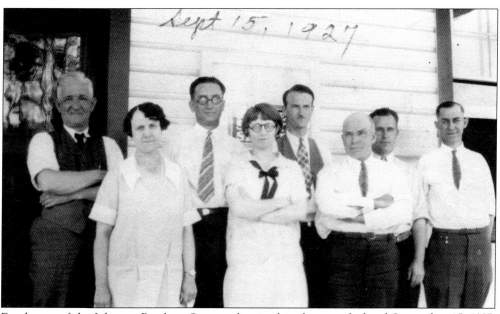

Employees of the Johnson Brothers Store gather in this photograph dated September 15, 1927. From left to right are (first row) Mrs. H. (chief stenographer), Stella Fogary (sub-clerk), and Roy Hull (storekeeper); (second row) Henry Swartz (assistant storekeeper), Harry Hersmeyer (first clerk), Ray Henderson (clerk), Jack Hevertz (stocking clerk), and Frank Smith (chief clerk). Not pictured are H. Pearsall (timekeeper) and V.C. Decker (senior clerk).

Brothers Jim and Bob Hull stand with their dog Kidd across from Carsten's Meat Market at 207 Barksdale Avenue. Built in 1917, it was one of several meatpacking/retail stores in the region owned by Thomas Carsten. First operated by Murray Taylor, Ob Gustafson was the meat cutter for many years. Charlie Summers began by managing the office but became sole operator until its closing. It became DuPont Town Hall in 1952.

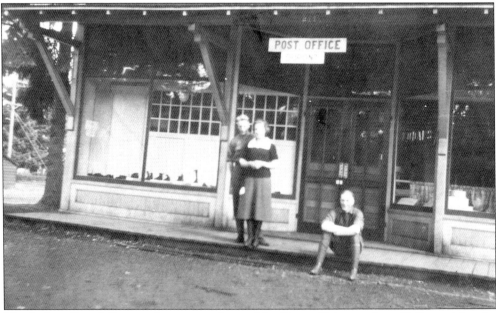

The DuPont Post Office was first operated out of the Howard Mercantile in DuPont. After the Johnson brothers purchased the store, they relocated the office to the former Fisher building and remolded the old store into the "Old" Bavarian Apartments. This was a logical move. Carl and Eva Holmes had lived above the mercantile, and G.B. Skewis had rented the upstairs as apartments while he lived in Tacoma.

The DuPont Post Office, constructed in 1967, became a landmark building in DuPont and sat near the local gas station at the entrance to the village. Located at 116 Barskdale Avenue, it was the town's first dedicated post office. The structure is now home to DuPont Barber & Beauty and stands next to Iafrati Park, which is named for Mayor John Iafrati.

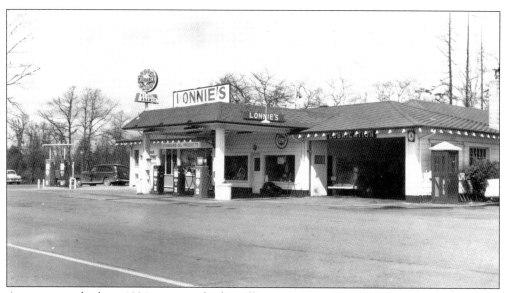

A garage was built in 1924 just outside the village entrance, owned by former plant manager Dwight S. Robinson. Hired in the 1920s, Elvie Picton bought the station in 1945. Employee Lonnie Young bought the garage in 1955. Photographed in 1958 before its 1965 modernization, it was located across the street from the current gas station at 100 Barksdale Avenue. Built in 1977, the station has been a grocery, dry cleaners, and Korean market.

On August 29, 1959, the DuPont plant celebrated 50 years of operations with speeches, a catered dinner, and an escorted tour of the plant. About 550 employees, retirees, and their families attended the event. From left to right are company officials Frank Beers (manager, 1923–1945), Fred Wilson, William Lapsley, George Ogren, Henry Hansen, U.C. Decker, and Herb Withrow in front of the main office building.

This mid-20th century road sign welcomes visitors to DuPont. In 1943, one hundred fifteen of the plant's 280 employees lived in the village. After the war, workers began commuting in larger numbers from Tacoma, Tillicum, and the Nisqually Valley. In 1951, the DuPont Company offered to sell its houses to their residents. Retirees and widows of employees were allowed to continue paying a nominal rent set at $18 to $20 per month.

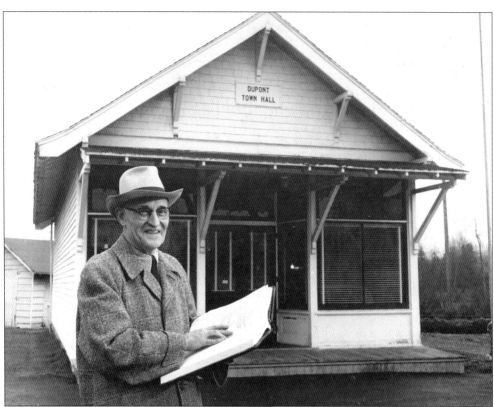

Once DuPont residents owned their own houses, some form of government was required, and the community voted to incorporate as a city in 1951 with H.L. Harrington as its first mayor. The former Carsten's Meat Market became the town hall. The second mayor, Harry Robinson (pictured), served nearly two terms, resigning in 1968 due to ill health. Robinson Park, next to the DuPont Historical Museum, is named in his honor.

Elton Grant was picked as fire chief for the volunteer fire department when the city voted to incorporate in 1951. The fire department, headquartered at 303 Louviers Avenue (1960s–2008), consisted of about 20 men and purchased its first fire engine at the time. Grant was appointed to finish Mayor Robinson's term and died in office in April 1969. Councilman John Iafrati was appointed to finish Grant's term of office.

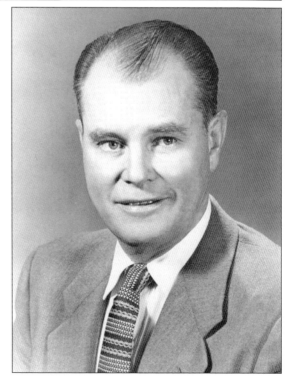

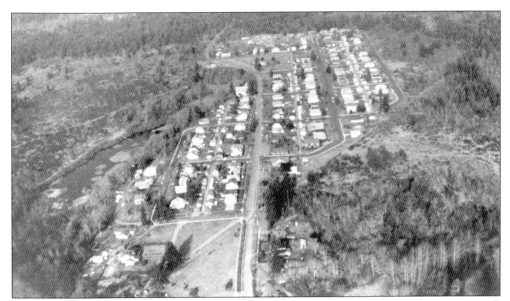

At incorporation, the DuPont Company donated the water, sewer, and electrical systems as well as several lots for parks and children's playgrounds. In 1972, the city annexed all land belonging to the company, increasing the acreage of the town from 82 to 3,192. This aerial view shows the city in 1964, facing northwest. Northwest Landing was later built to the left.

Mayor John Iafrati (far right) was reelected in 1971. After a special election in 1970, the city replaced the company's expired 1951 protective covenants with ordinances. Iafrati Park, near the entrance to DuPont Village, is named for John and Ruth Iafrati and was dedicated in 2002. John had helped purchase the land, and Ruth was active in the formation of the DuPont Historical Museum and the DuPont Garden Club.

Four

COMMUNITY LIFE

It takes more than homes and businesses to make a community, and the DuPont Company took this into account when constructing DuPont Village. Over time, the company provided land for a playground and parks. It also held an annual picnic for employees and their families.

In addition, the company built a community clubhouse where the villagers could relax and socialize after work. The clubhouse hosted many events and even showed movies once a week in the early years. Later, residents went to Fort Lewis to see movies.

The DuPont Clubhouse no longer exists, but another important community institution, the First Presbyterian Church of DuPont, remains. Now called the DuPont Community Presbyterian Church, it continues to provide both a place to worship and a community meeting place. Once Fort Lewis opened, some residents began to attend services on base.

Organized sports were also an important part of community life. DuPont had several baseball teams that competed throughout the region. Others enjoyed bowling at the clubhouse. The company sponsored an annual national bowling tournament, pitting teams from its plants in a friendly rivalry.

Additionally, DuPont residents formed clubs. These included organizations such as the church's DuPont Triangle Club, founded in 1932, which organized speakers and other entertainment for men, and the Rod and Gun Club, formed in 1950, which focused on hunting. The Women's Association of the DuPont church aided Fort Lewis soldiers from 1950 to 1969, including making cookies and candy and mending uniforms. Founded in 1956, the DuPont Garden Club published a telephone directory and maintained hanging baskets along Barksdale Avenue during the summer and Advent wreaths during the holidays.

DuPont kept close ties with nearby areas. From 1966 to 1976, the town had *The Villager*, a bimonthly newsletter. A village correspondent also provided news to Tacoma newspapers, to which many residents subscribed. Roy C. Hull provided this service in the 1920s.

DuPont survived a major earthquake on April 13, 1949, that caused $1,000 in damage to the plant. But nothing shook the community institutions that helped make life livable. It is perhaps appropriate that the former Johnson Brothers Store is now a community center.

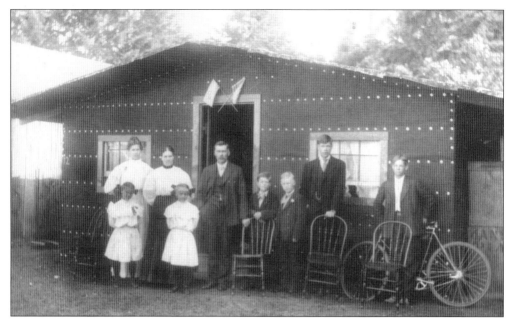

John and Margaret Bergstrom gather in front of their Old Town home with their children Ida, Bill, Dave, Axel, Inor, Minnie, and Ellen (not pictured is Mary Bergstrom). Swedish immigrants who transferred from DuPont's Barksdale plant, they became part of the new DuPont community. Residents used the former Huggins house (which had been Fort Nisqually's chief factor's house) as a community clubhouse, holding dances, weddings, church services, and other activities there.

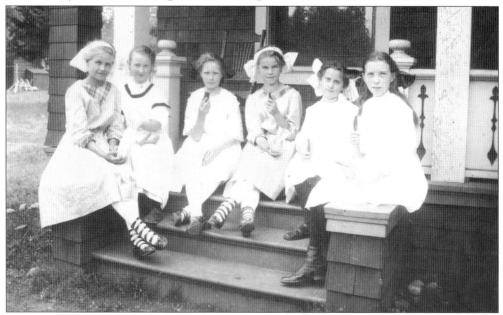

DuPont employees came from across Europe and the United States. Most of the girls in this 1910–1911 photograph are unidentified, except for Ethel Ogren and "Aunt Mary." Ethel was one of Gustave and Clara Ogren's nine children. Born in Sweden, the couple moved to DuPont from the company's Barksdale plant in 1909. Gust headed the Acid Department from his arrival until his 1929 death. Ethel later married William Bergstrom.

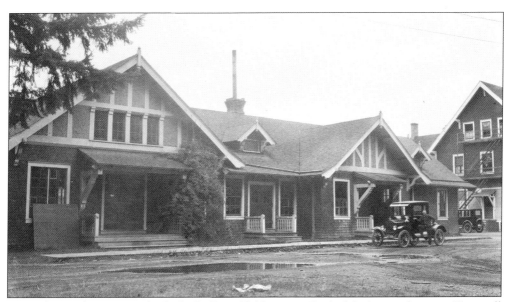

Around 1910, the company built the DuPont Clubhouse on Barksdale Avenue between Hopewell and Penniman Streets, next to the hotel. The clubhouse housed a dance hall, pool tables, barbershop, and library. Many events were held here, including card parties, bingo, dances, dinners, and meetings. Soldiers often visited the clubhouse.

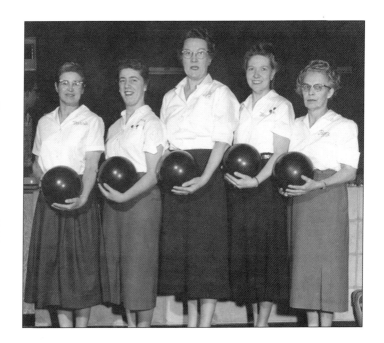

The DuPont Clubhouse included a two-lane bowling alley, which was a popular gathering place for men and women in the town. From left to right, Marcia Laughbon, Lynn Forgey, Maryann Zurfluh, Peg Henton, and Sally Lanham enjoy bowling in this undated photograph. The DuPont Company held an annual inter-plant tournament. High scorers at DuPont competed against other plants across the country for the trophy, sending their results by telegram.

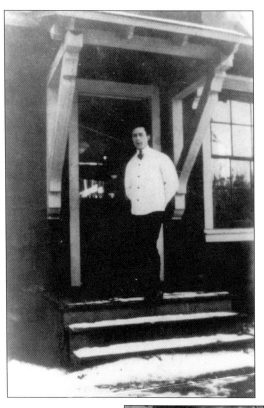

The clubhouse was a popular meeting place. The barbershop provided a good place to relax and socialize for DuPont workers. Barber Mike Cerro stands in front of the shop's outside entrance in December 1921. A tree fell on the building during the 1962 Columbus Day storm. In 1964, the company offered the city the clubhouse for $1, but the mayor refused due to maintenance costs, and it was razed.

This photograph, taken in the late 1950s, shows a Fort Lewis Teenage Club dance. Robert Bruno (center left), Richard Bitger (on left, facing camera), and Jann Robinson (center right) have been identified. DuPont teens were able to attend this club as well as the teen club at the DuPont Clubhouse. Run by I.I. McDaniel, the DuPont Teen Club had a jukebox and soda fountain and held dances.

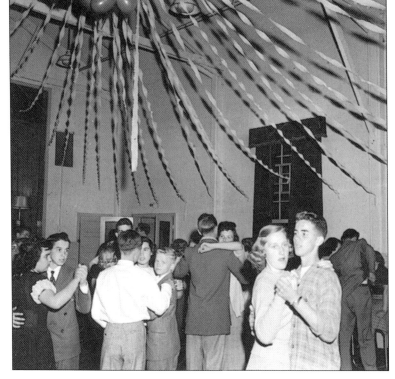

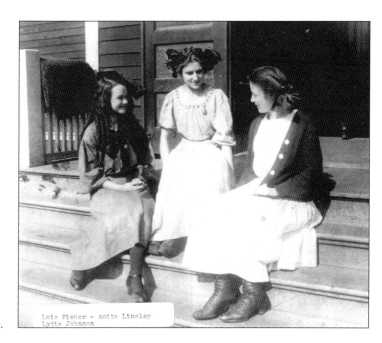

Lois Fisher, Anita Linsley, and Lydia Johnson are sitting on the steps of the DuPont School around 1912, soon after the building's construction. DuPont residents usually stuck close to home for entertainment and shopping, though many regularly traveled to Tacoma. After the construction of Fort Lewis, residents visited the base occasionally to see movies, as DuPont had no theater. Lois Fisher was the daughter of storekeeper Alfred Fisher and his wife, Janie.

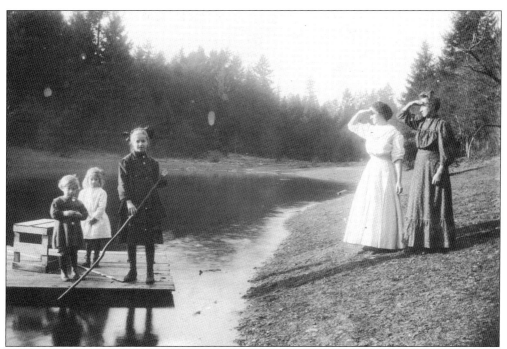

This real-photo postcard records a scene at Edmond Marsh in the DuPont area in 1911. The people have been identified as (in unknown order) Elaine, Vivian, and Lawrence Armstrong and Ellen Bergstrom. Known as "the swamp," Edmond Marsh was a popular place for children to sail (often unseaworthy) homemade rafts. During the winter, people ice-skated and had bonfires there. The most popular sledding spot was by the Johnson Brothers Store.

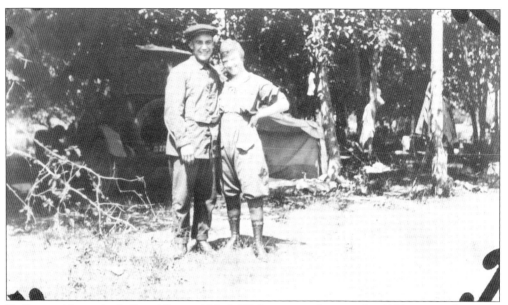

DuPont residents, including Allie and Herb Withrow, seen here in the 1920s, enjoyed visiting nearby lakes and streams. These included American Lake; Muck Creek on Fort Lewis; and Hicks, Patterson, and Long Lakes in what is now Lacey. Some residents kept boats on the beach near the company wharf at the mouth of Sequalitchew Creek and enjoyed clamming, crabbing, and fishing. Herb, a machinist, married Olava "Allie" Guernemoen in 1921.

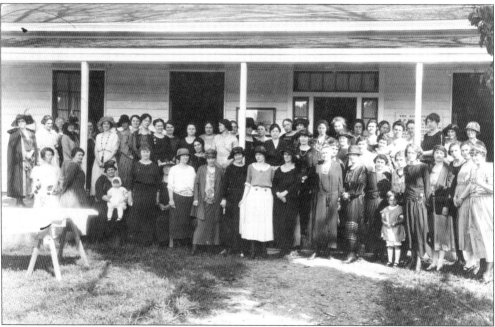

This photograph, dated April 25, 1923, shows the Women's Club meeting at the historic chief factor's house. The club formed in 1919, with Mrs. Willard Smith, wife of the assistant manager, as its first president. The club's main project was to create a playground for the community's children along with a recreational program funded by a public subscription drive that collected about $1,000 for equipment.

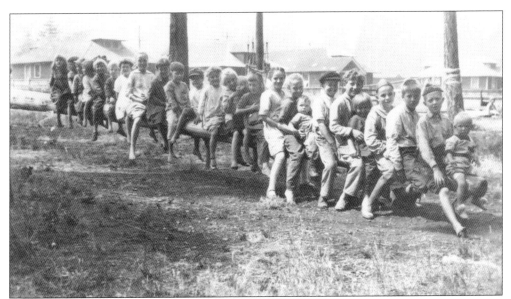

The DuPont Company donated and surveyed five acres for a community playground at the 500 block on the north side of DuPont Avenue, bounded by railroad tracks. Volunteers of all ages worked to set up the park. These children gather on a log at the playground for the camera.

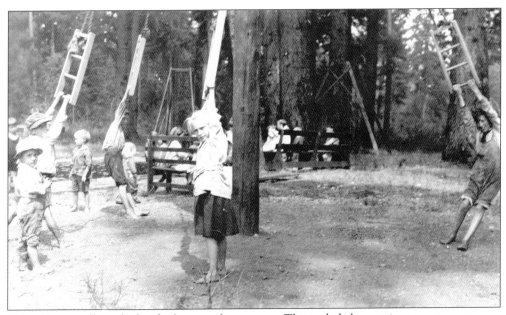

The park was well supplied with playground equipment. This included two swings, two teeter-totters, a sandbox, slide, wading pool, brick and iron stove, picnic tables, two ball diamonds, a basketball court, two three-set turning bars, a six-seat pump-a-way, and a bouncing log. Pictured are the "giant strides." Grabbing onto the bars at a run, youngsters could swing around the pole.

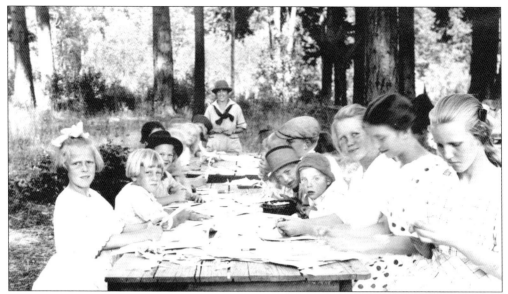

In 1920, the Woman's Club hired Frieda Boettcher, a graduate student from Kenosha, Wisconsin, to run the summer recreational program. Using it as her master's thesis, she organized games, events, and activities. In 1921, Huora "Bonnie" Bonnell, physical education and music teacher at the DuPont School, took over. She is possibly the woman leading a group of girls cutting paper dolls in this 1921 photograph. The summer recreational programs ended in 1924.

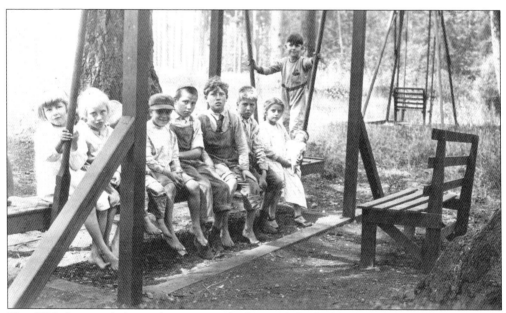

This 1920 photograph shows a lawn swing, which provided a shady resting place on the community playground. The playground was a source of community pride. The club presented a pictorial report at the 1919 Washington State Federation of Women's Clubs meeting, and Roy Cornelius Hull, village correspondent to the Tacoma newspapers, sent them regular articles about playground activities. The playground was also featured in national company publications.

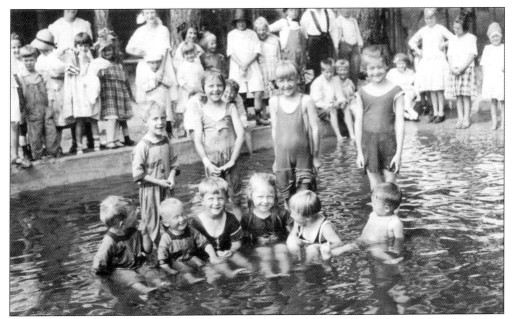

A group of children gather at the playground's wading pool in 1920. The town kept a wading pool at the DuPont playground. More popular for older children and adults was a swimming hole along Sequalitchew Creek, located about 200–300 yards from the DuPont plant fence. The creek passed under the railroad tracks, providing a large recreation area complete with picnic tables, diving platforms, and dressing rooms.

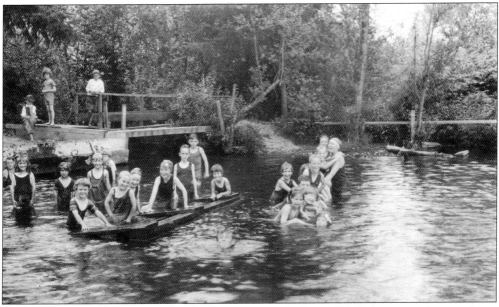

These children are learning to swim at the swimming hole in 1920. Fishing was also popular at the spot. In 1921, the company deemed use of the swimming hole as hazardous to the village water supply. The pool was closed, and all facilities were razed. Fort Lewis now diverts the water that comes out of Sequalitchew Lake to Solo Point, so water no longer flows through the spot.

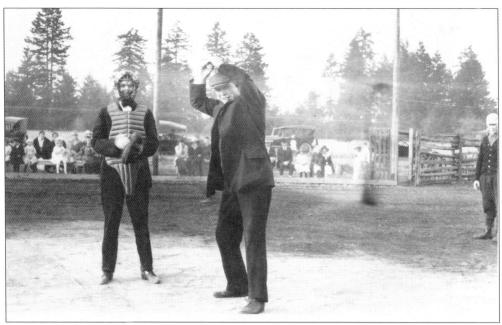

Patrick M. Harrington and Warren W. Witmer open the baseball season in 1921. Witmer was assistant plant manager from 1919 to 1921, and Irish-born Harrington was powder foreman. Community and company baseball teams were popular in the early 20th century. By the 1930s, DuPont had three separate baseball teams that played against each other during the week and against Fort Lewis teams and the Nisqually Tribe's team on Sunday.

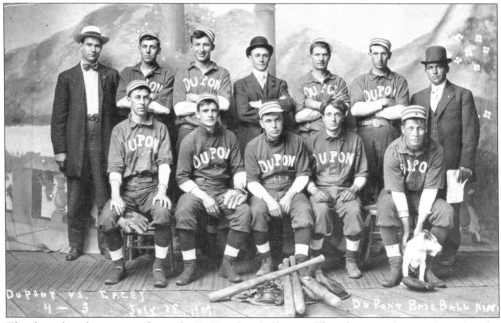

This formal studio portrait shows the DuPont baseball team. This photograph was taken after the 4-3 victory of DuPont over Lacey (probably St. Martin's College) on July 25, 1909. Arby Jurisch was team manager that year, and the team won most of its games against other South Sound community teams.

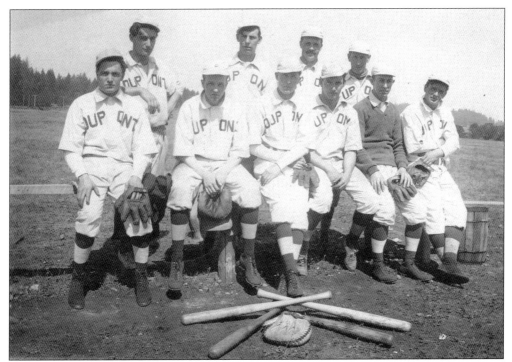

The DuPont baseball team gathers on the field for a group picture. In early years, teams played in a large field near the plant gate. Later, teams relocated to the DuPont School's field. With the creation of Camp Lewis, DuPont also played against military baseball teams. In addition, DuPont had community basketball and bowling teams as well as school sports teams.

DuPont Boy Scouts in the 1920s wear homemade cardboard armor outside the DuPont School, ready to leave for the Rotary Boy Scout Day Celebration in Tacoma, where they won second prize. Boy Scout Troop No. 62 was founded in May 1923 with F.C. Wilson, principal of DuPont School, as first scoutmaster. Longtime DuPont teacher and school administrator Wendell Laughbon was scoutmaster from 1927 to 1940.

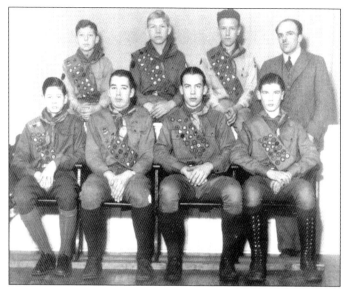

This group picture of Eagle Scouts was taken sometime between 1933 and 1941 when Gov. Clarence Martin presented their Eagle Scout badges. From left to right are (first row) Robert Prince, Jack Lancaster, Roy Forgey, and Robert Johnson; (second row) Edward Comulada, John Comulada, Robert Edgar, and coach Wendell B. Laughbon. William Nicklason, who later worked on the Manhattan Project, earned DuPont's first Eagle Scout award in 1928.

This display, one of five tables, took first place at an arts and crafts contest held by Cub Scout Pack No. 62. The pack was first organized in December 1941 with the DuPont School as its sponsor. Wendell Laughbon served as first cubmaster from 1941 to 1945. Initial enrollment was 32 boys. The pack was later sponsored by the Fort Lewis Child Welfare and the Fort Lewis Dad's Club.

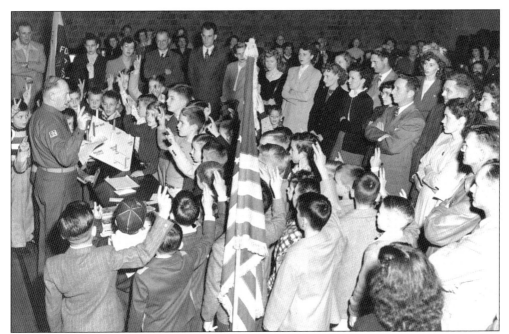

Hans Schinnell was cubmaster from 1946 through 1960. Here, he swears in Cub Scouts on Initiation Nite. Troop No. 62 was sponsored by various private organizations after the school and Parent-Teacher Association were no longer allowed to sponsor it in the 1940s. This included the Fort Lewis Welfare Association, Youth Activity Council, Holy Names Society of Fort Lewis, and Fort Lewis Dad's Club. New packs formed in the 1960s.

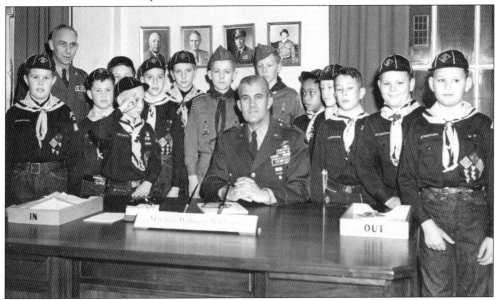

In February 1957, DuPont Cub Scouts visited Maj. Gen. William Quinn (commander of Fort Lewis) to present him with an invitation to their upcoming annual Cub Scout court of honor dinner, where Scouts would receive their awards and badges. Sgt. John Walls (far left) was a Scout leader. Scouts took regular hikes at American Lake and to the DuPont wharf, staying overnight at the "Scout Shack" on the DuPont beach.

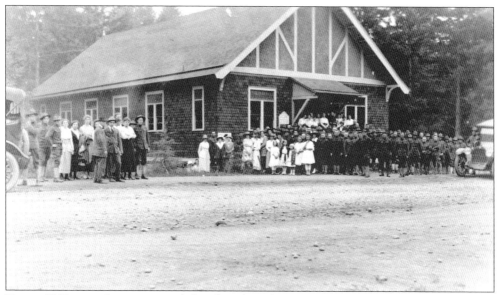

During 1909, a nondenominational church and Sunday school met in the old chief factor's house. A Presbyterian church was established in 1910. The King's Daughters raised much of the funding for a new church building through bazaars, teas, and bake sales. A 1916 community subscription raised the rest, and the church was built in 1917. Known as the "Campside Church" during World War I, many soldiers from Camp Lewis attended.

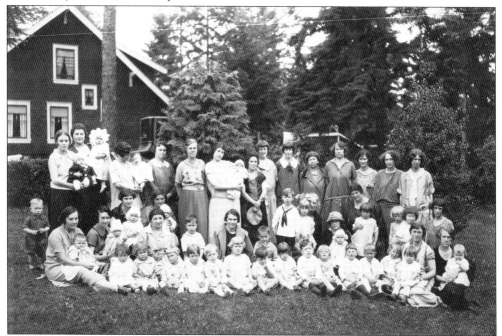

Children are an important part of the DuPont Community Presbyterian Church. These mothers and their children, photographed around 1923 (a post–World War I baby boom), are from the church's "cradle roll," or child care. The church was built for $4,809.06. With the DuPont Company's permission to build, assistant plant manager Willard A. Smith designed the building, and many volunteered to construct it. The first services were held on March 7, 1917.

These children were the cradle roll graduating class of 1923. In 1928, the DuPont Company moved a house from 203 Barksdale Avenue to a site next to the church to serve as a manse. The company deeded the land for both the church and manse to the DuPont Community Presbyterian Church.

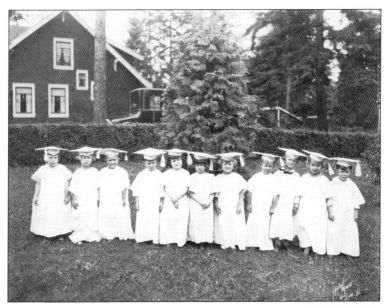

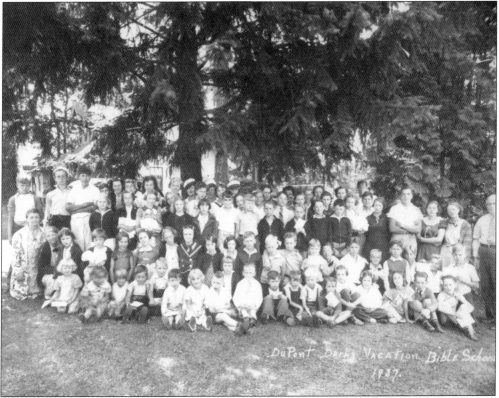

The DuPont Daily Vacation Bible School students and volunteers gather for the camera in 1937 near the church. It was a continuing program to teach basic Christian lessons to children during school vacations. Earlier, the Rev. Harry Templeton was pastor during World War I. He led a group of children, nicknamed the "Templeton Tots," who entertained the troops with vaudeville performances at Camp Lewis.

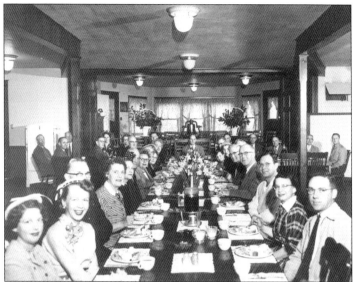

Wanting a bell to call people to worship services and Sunday school, the church, sometimes affectionately known as "the Little Brown Church," obtained a surplus locomotive bell from the Northern Pacific Railroad. The bell was presented and dedicated at a special noon dinner on June 12, 1955, on Children's Day. Currently the bell is undergoing repairs to be used again.

Starting in 1970, Advent wreaths were hung on lampposts through DuPont Village. Before Advent Sunday, residents gathered fresh greens and made wreaths. The celebration opened on Advent Sunday with a procession of carolers down Barksdale Avenue and a reception at the Presbyterian church. In this 1978 photograph, Mayor Iafrati thanks Pola A. Audre, choral director for the Advent program. Advent wreaths are still hung in the village for the holidays.

In the 1960s and 1970s, an annual Pioneer Pow Wow was held in Robinson Park around the Fourth of July. A royal court was chosen from Laughbon High School. Here, the 1970 court visits Gov. Dan Evans. From left to right are (first row) princess Karen Smith and maidens Katherine Suzuki and Carolyn Bass; (second row) attendant Wanda Jean and pioneer lady Marcia Laughbon. Princess Mary Ann Shaver is not pictured.

The Pow Wow included games, concerts, historic site tours, stagecoach and pony rides, and free ice cream. On June 25, 1971, the court presented Brig. Gen. John Boyd Coats Jr. (Madigan General Hospital commander) with a commemorative button and an invitation to the festivities. From left to right are princess Cindy Reed, queen Ethel Lumsdon (for whom Ethel Lumsdon Park is named), princesses Ky Booth and Linda Scurlock, and General Coats.

May Munyan moved to Washington in 1920, where she married Carl Gaul, a Nisqually Valley farmer. They had three sons. After Carl's death, she married Lester Munyan and moved to DuPont in 1959. She was the editor of *The Villager*, a bimonthly newsletter (1966–1976.) Interested in DuPont history, she helped found the DuPont Historical Museum and in 1972 published *DuPont: The Story of a Company Town*.

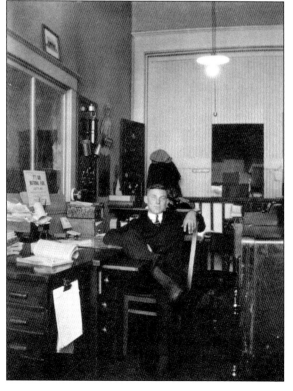

Hans Schinnell, a storeroom clerk, relaxes in the DuPont Company's main office during the 1930s. He worked for the company for over 41 years and also was a Boy Scout leader in the community. Like many others, he remained in DuPont after retirement.

Five

SCHOOLS

The DuPont school system has changed very much in its many years. Some children of Hudson's Bay Company employees were tutored at home or sent to far-off boarding schools. From 1839 to 1842, the Methodist mission held a small school for local children, including Native Americans.

American settlers and former HBC employees formed School District No. 7 around 1860 and built a school at a site in the current Iafrati Park in Historic DuPont. This school was replaced in the 1880s by a larger building that was constructed at the edge of what is now the Eagles Pride Golf Course.

Things changed rapidly with the arrival of the DuPont Company and the founding of DuPont Village in the early 20th century. School was temporarily held in a two-room tar paper building before a new schoolhouse could be constructed in 1911 at the site of what is presently the Barksdale Station commercial area. This location was the home of an expanding DuPont School complex until the mid-1970s.

The 1911 school proved insufficient for the influx of students from the newly formed Camp (later Fort) Lewis. To meet this demand, in 1917 a new school was built on the grounds of the 1911 schoolhouse. By the late 1930s, the DuPont School District officially included some Fort Lewis students as well as DuPont children.

However, DuPont lacked a high school for students in grades 10 through 12. These students attended Tacoma high schools. DuPont opened a high school in 1963, named for Wendell B. Laughbon. This added to a feud with the Clover Park School District concerning jurisdiction over Fort Lewis. After a series of legislative and court battles, Laughbon High School lost its federal funding and was forced to close in 1973. The building was later used by the City College of Seattle and the Evergreen Lutheran School until its demolition in January 1989.

In 1975, the DuPont School District consolidated with Steilacoom and Anderson Island School Districts. Currently, DuPont has two schools—Chloe Clark Elementary School opened in 2001, and Pioneer Middle School in 2008.

Students in School District No. 7 (Fort Nisqually area) attended class in homes until volunteers built a schoolhouse around 1866 at what is now 100 Brandywine Avenue. Mrs. Settle, a widow, was the first teacher. Teachers occasionally boarded with Edward Huggins at the chief factor's house. From 1866 to 1899, the district included 31 teachers and 122 students. O.H. White, clerk of the school board at the time, made this drawing.

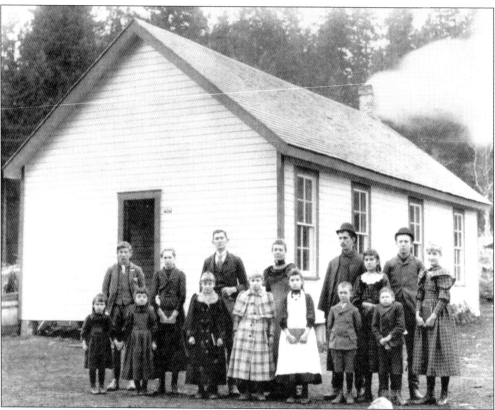

In 1885, the school relocated nearly three miles from the 1866 school to a more central site near the current Eagles Pride Golf Course. Homesteader Daniel Mounts donated the land and supervised construction. Called the Mounts Road School, it was used until DuPont established its own school. The 1885 building was moved downhill, converted into a ranch house, and burned down by the early 1970s.

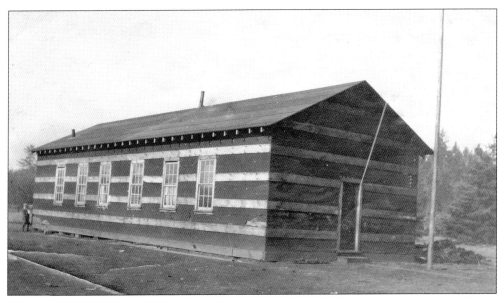

When the DuPont Company came to the area, families needed a school closer to home. Classes were first held in the chief factor's house. Around 1907 or 1908, the company built a 30-by-60-foot tar paper building near the plant gate in Old Town to use as a temporary school. The interior was divided in half by a cretonne curtain. Drinking water was carried up from Sequalitchew Creek.

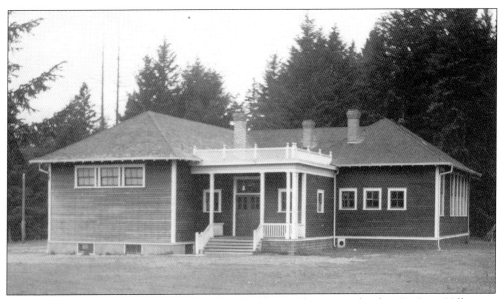

School District No. 7 replaced the tar paper building with a new school in DuPont Village in 1911. Located at what is now Barksdale Station, this area was home to the DuPont School for over half a century. A three-room structure, the 1911 school building, seen in this postcard, had the modern convenience of gas lighting. Students also attended from nearby logging camps and the Nisqually Valley.

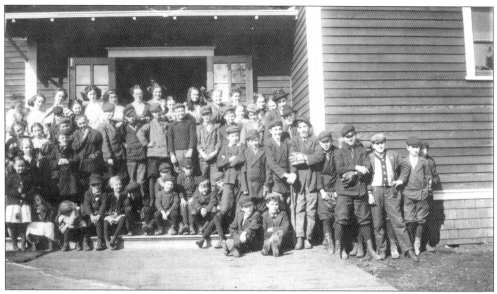

DuPont students gather for a class portrait outside the 1911 schoolhouse. It was used for four years as the community's only school. In early 1917, Pierce County voted to give the federal government 70,000 acres at American Lake for a military post. Camp Lewis was quickly constructed to train thousands of soldiers for World War I. This increased the number of students in the area.

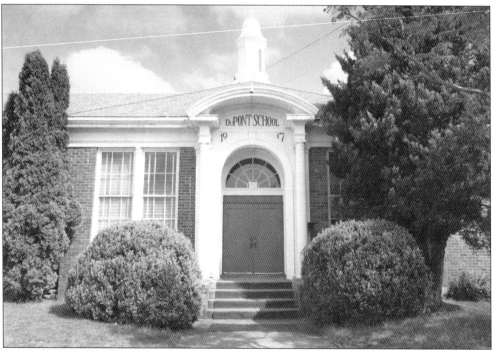

The influx of students from Camp Lewis families overwhelmed the existing DuPont schoolhouse. School District No. 7 approved a $40,000 bond to build a new school on the 1911 schoolhouse's grounds. Constructed in 1917, this Federal-style brick building housed four classrooms and an auditorium. Locals bragged that it was one of the best built schools in the state. Its cupola was later moved to the DuPont Community Center (Johnson Brothers Store).

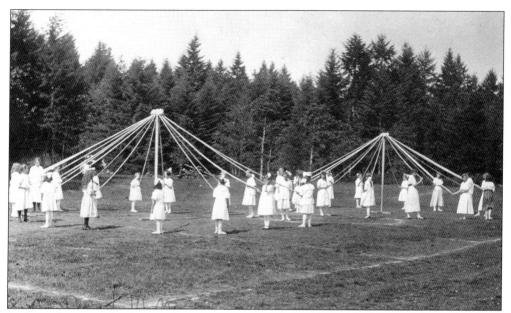

In the early years, schools served as community centers in addition to being places of education. Here, a group of DuPont schoolgirls prepare to dance around the Maypole on May Day in 1917. A European springtime tradition, the pole would be covered in an intricate braid of colored ribbons by the time the dance was completed.

After World War I, Camp Lewis continued to expand. Students from nearby Camp Murray (National Guard) also started attending the DuPont School in 1920. That year, the school added three classrooms and a furnace room for $65,739.00. Three portables (pictured), made from Camp Lewis barracks, were turned into a gymnasium, industrial arts shop, and three additional classrooms. The 1911 building was turned into a kindergarten, lunchroom, and home economics classroom.

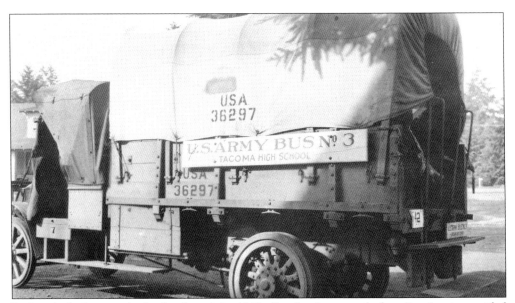

DuPont lacked its own high school until the 1960s. Surplus Army trucks from Fort Lewis provided transportation to send students from DuPont and Fort Lewis to Lincoln High School in Tacoma. DuPont students attended Lincoln until 1933. Later, they went to Stadium High School from 1933 until World War II. This photograph was taken in 1921.

Students wait for the bus to attend high school in Tacoma in 1921. To save gasoline and tires during World War II, students were transferred to the much closer Clover Park High School in Lakewood, which students continued to attend until 1961.

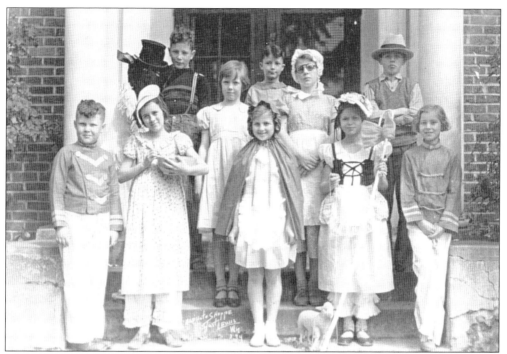

The Parent-Teacher Association (PTA) has long been important in DuPont. Growing out of mothers' groups, the local association was founded in June 1920. In 1934, Sue Youngbluth arranged for this group of third through ninth graders to perform at a PTA meeting. The children dressed as Mother Goose characters like Little Miss Muffet, Little Red Riding Hood, Bo Peep, and the Big Bad Wolf.

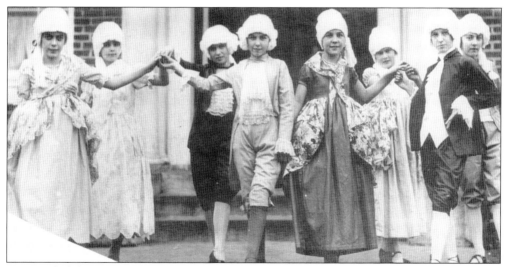

Patriotic holidays were important school events. Here, a group of seventh grade girls don period costumes and homemade white powdered wigs in 1926 to honor the birthday of George Washington, first president of the United States and the state's eponym. The children are, from left to right, Beth Wilson, Betty Wiley, Mercedes Guelfy, Helen Bakke, Louise Manley, Edith Munyan, Verna Trimble, and Harriett Chorlton.

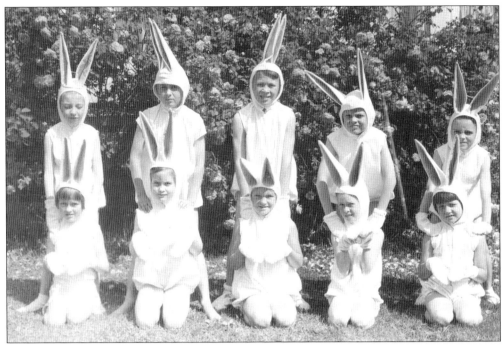

School taught lessons and held programs based around national patriotic and popular holidays. Here, a group of DuPont children dress up as bunnies for a primary school program celebrating spring and Easter.

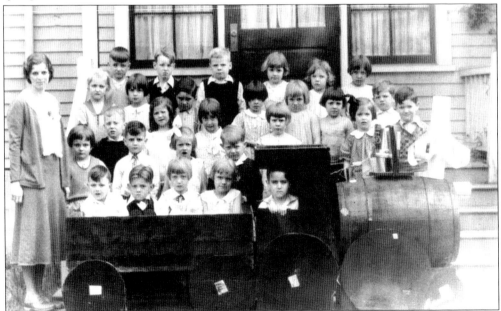

Madeline Freece's 1931–1932 kindergarten class gathers for a class picture with a model train by the 1911 building, which was torn down in the 1940s. George La Caille is the engineer. DuPont had no preschool until the Great Depression, when Clara Beers led a small, short-lived preschool that grew out of the cradle roll at DuPont Community Presbyterian Church. From the 1940s to the mid-1950s, the Woman's Club also ran a preschool.

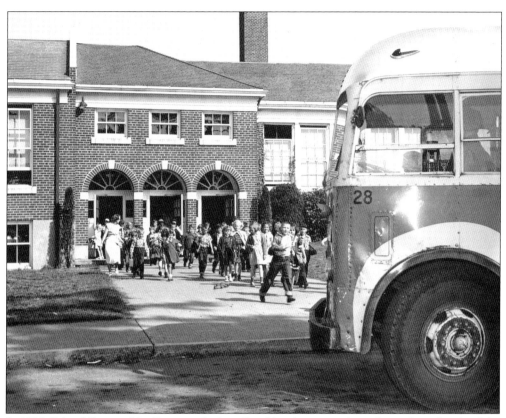

In 1936, School District No. 7 was made the official kindergarten through ninth grade school for Fort Lewis through an agreement with the fort's commanding general. With the aid of the Public Works Administration, DuPont added a gymnasium, science laboratory, library, and classrooms to the building in 1938, removing the portables. The World War II buildup strained facilities again. The school added a cafeteria, music room, porch, and six classrooms in 1942.

The library at the DuPont School waits for students. This library was built in 1938 and provided workspace as well as a variety of fiction, nonfiction, and reference works for reading.

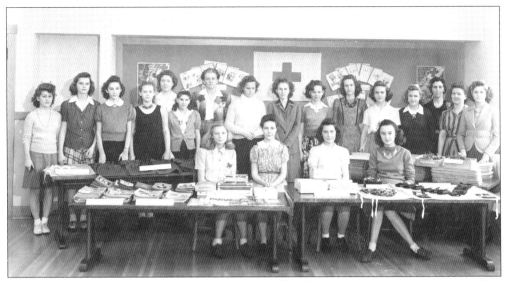

During World War II, American schools formed Junior Red Cross clubs to assist the war effort. This 1942 photograph shows the sewing members of the DuPont School Junior Red Cross displaying items they have made such as card table covers, kits, and picture books. Teacher Dorothy Stoll (second row, third from right) taught home economics, Spanish, and state history for many years, coached girls' basketball, and led Girl Scouts.

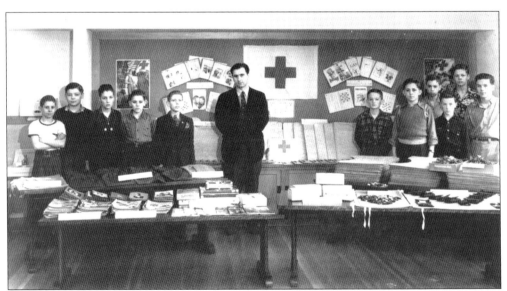

Boys also participated in the Junior Red Cross. Junior Red Cross "shop boys" gather for this 1942 photograph. The adult at center is leader George Kenoyer. He was scoutmaster of Troop 62 from 1942 to 1945 and 1950 to 1955. Kenoyer taught mechanical drawing and shop at DuPont Junior High School for decades. Here, they proudly display items they have made to help the war effort. Students also gathered scrap metal.

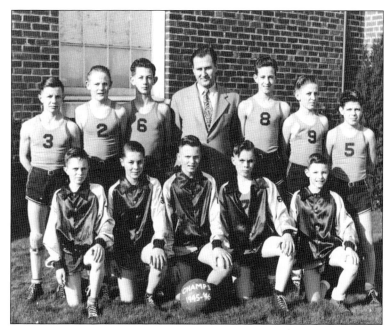

The 1945–1946 DuPont Junior High School basketball team gathers for this picture. They were Pierce County champions that season, coached by George Kenoyer (second row, center). This team included Dick Gardner, Ken Braget, Allen Grant, Bill Henton, Louis Finch, Gilbert Long, Cameron Surface, Stanley Johnson, and Henry Stickerod.

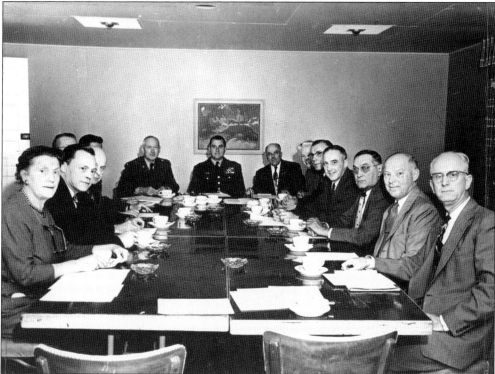

In 1953, School District No. 7 became the DuPont–Fort Lewis School District. Students attended elementary school on the military base, DuPont Junior High School, and Clover Park High School. The district board meets with the Washington State Board of Education in this undated photograph. Both civilians and military officers served on the district board. In 1958, the district constructed an administrative building. After the district closed, it became DuPont City Hall.

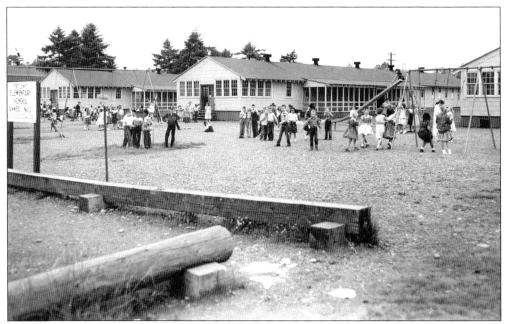

The majority of students in the DuPont–Fort Lewis School District were military dependents. In 1947, the district opened an elementary school in the former Third Infantry Division headquarters on base. A World War II hospital alongside the Pacific Highway became an eight-building annex. This annex was used until 1966. In 1950, Congress allocated funds to aid public school construction, which allowed several schools to be built on the base.

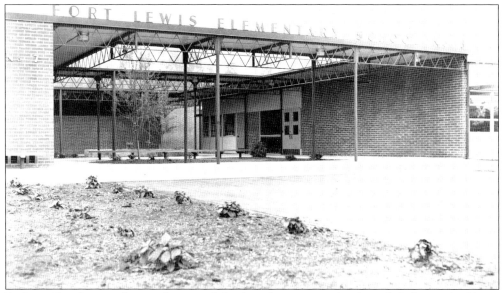

DuPont–Fort Lewis split jurisdiction of the fort elementary schools with Lakewood's Clover Park School District. Of the five elementary schools on the fort, Clover Park ran two while DuPont–Fort Lewis operated three. DuPont managed Greenwood (built in 1953), Parkway (1957), and Clarkmoor (1957). This is Clarkmoor, also known as school No. 3. Built in campus style with covered walkways between classrooms, Clarkmoor became a child development center.

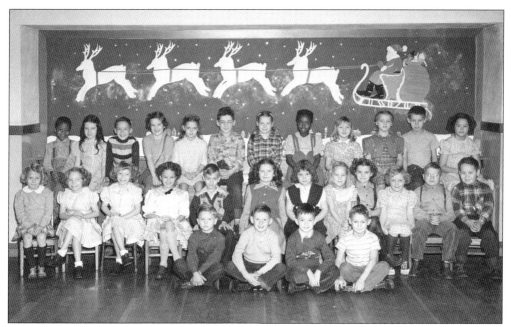

Ruth Bryan's first grade class poses by a Christmas display at their school in 1949. By the 1950–1951 school year, DuPont had an enrollment of 376 elementary students, most of whom were military dependents. African American students from Fort Lewis began to attend DuPont School after the Army was desegregated by executive order in 1948.

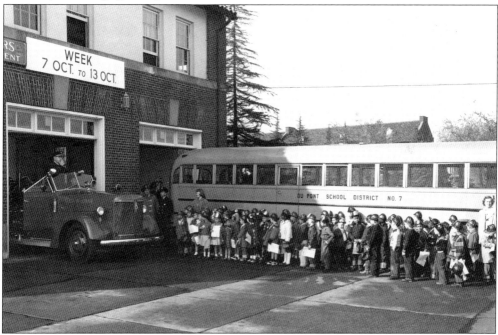

Students at DuPont schools often took field trips to nearby Fort Lewis. The fathers of many of these students served in the military. Here, a group of kindergarten children visit the Fort Lewis Fire Department headquarters on October 5, 1946, as part of Fire Prevention Week. They toured the fire station and learned about fire safety.

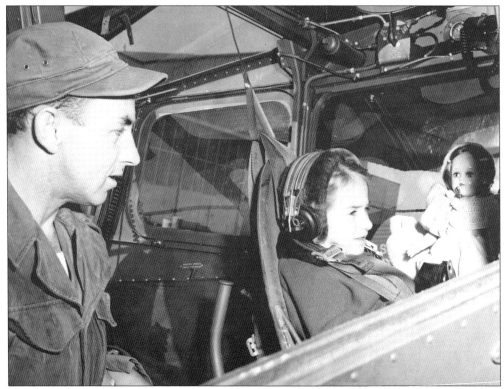

DuPont teacher Ruth Bryan took her kindergarten class to visit Gray Field on Fort Lewis, probably during the 1950s. Here, a military member shows off a plane while a little girl sits in the pilot's seat. Note the stylishly dressed doll also admiring the cockpit.

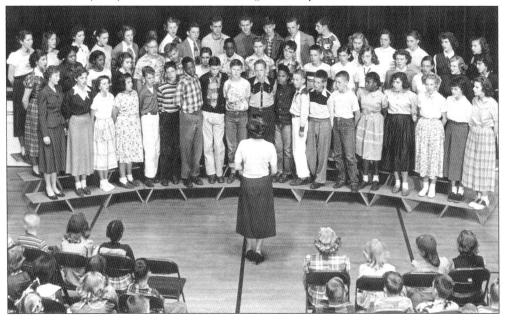

A group of DuPont Junior High School students practice for a choir contest in May 1952. The DuPont School also had a band and orchestra. (Courtesy of Tacoma Public Library.)

The DuPont School gymnasium hosted many events, from Boy Scout meetings to dances and plays. Here, Rumples the elephant greets visitors at a circus-themed event.

Clubs were an important part of school activity. They included academic, service, sports, and recreational groups. Members of the Tip-Teens Club gathered in the DuPont Club's former ballroom in this January 1957 image to play a ball game on a Ping-Pong table, blowing the ball around with straws.

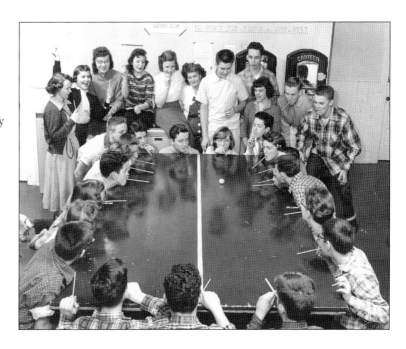

Students line up in the school cafeteria in 1951 under the careful eye of the lunch ladies. During the Korean War, many of these children's fathers were deployed overseas. Fort Lewis children formed the majority of DuPont School students after World War II. Often, many had to transfer mid-year as their families moved. This cafeteria was part of a 1942 addition to the main DuPont School building.

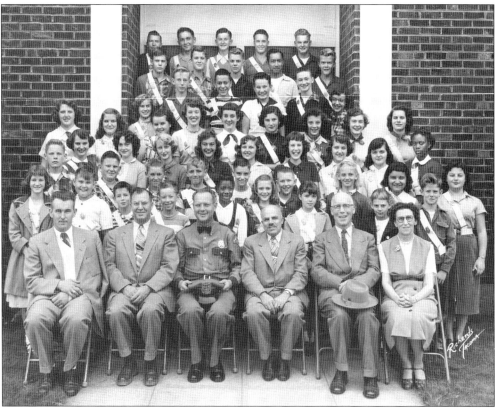

The DuPont safety patrol and school administrators gather in this c. 1953 picture. The post–World War II baby boom and Cold War growth of Fort Lewis swelled the enrollment of DuPont schools. In 1953, the school created a new cafeteria, lunchroom, and a multipurpose room (playroom/auditorium). Classrooms were paneled with blond wood and painted with pastel colors. Principal Wendell Laughbon is third from right. (Courtesy of Tacoma Public Library.)

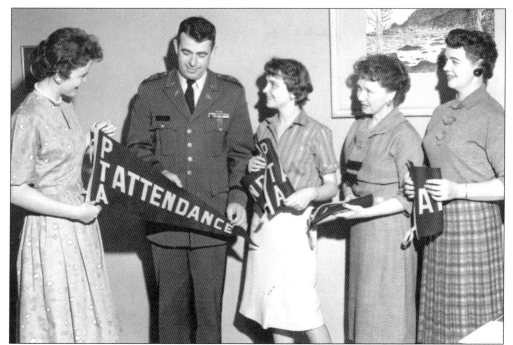

The PTA tries to encourage excellence. On October 20, 1960, DuPont School District PTA membership committee chair Maj. Charles Black handed PTA Attendance Awards to classes. From left to right are Catherine Thompson (fourth grade, TES No. 2), Mrs. Lavon Olander (fifth grade, Annex School), Ethel Tabor (fifth grade, Elementary School No. 1), and Virginia Muntman (Latin, DuPont Junior High School).

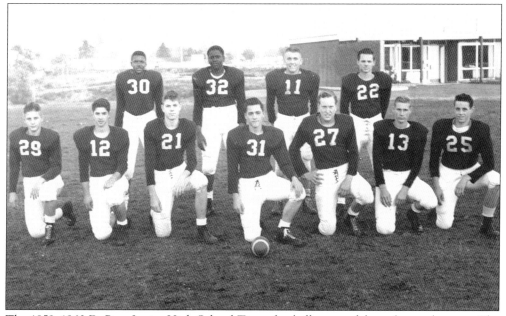

The 1959–1960 DuPont Junior High School Tigers football team celebrated a good season. The Tigers won all six of their games, taking part in the team's first championship. Coaches were Howard Fischer and Richard Jenkins.

The DuPont–Fort Lewis School District held many educational events over the years, including this science fair on March 23, 1962. Here, the two first-prize winners proudly display their plaques in front of their exhibits. Steven Albur (left) won the Senior High Physical Science Award for his ground effect machine (a flying platform) and Mike Albert (right) received the Junior High Biological Science prize for his milk bacteria demonstration.

In 1964, George Wenoyur (left) and artist Ellen Hughes (center) present Wendell Laughbon with a portrait. In June 1961, the district authorized construction of Wendell B. Laughbon High School, naming it after Laughbon (1902–1978), who had dedicated his entire career to the DuPont School. Built onto the existing DuPont School, students could choose between it and Lakewood's Clover Park High School. The nearby stadium was also named for Laughbon.

Fresh from graduating from Cheney Normal School in 1926, Wendell Laughbon (left) taught industrial arts, health, and physical education at DuPont Junior High School and also coached basketball and served as scoutmaster. In 1935, Laughbon became principal at the junior high and was elected district superintendent in 1938 (a position he held until his retirement in 1963). Here, on July 17, 1967, he shows Maj. William Harrigan how the school's intercom works.

Laughbon High School opened in 1961 for 10th grade. Eleventh and 12th grades were added in 1963 and 1964. Sixty-two students were in the first graduating class. Here, 1960s cheerleaders practice. The Panthers had boys' baseball, basketball, cross-country, football, golf, gymnastics, tennis, track, and wrestling teams. Girls organized a Girls' Athletic Association for basketball, field hockey, tennis, and volleyball. The first official girls' school team was tennis in 1968.

Laughbon High School formed a marching band in 1963. Receiving black and gold uniforms just a few days before, one of their first major appearances was a performance as part of the 1963 Daffodil Parade. Uniforms included black hats for concerts and white for marches. The band was led by teacher Cedric Hotchkiss. This photograph is of the band marching through a city, possibly Tacoma, for the Daffodil Parade.

Laughbon High School (LHS) participated in regional events. The school won second place in Division 6 for its "Players on Parade" Olympics-themed float at the Puyallup Valley Daffodil Festival on April 11, 1964. The year of the Tokyo Summer Olympics, the theme of the parade was "Nations on Parade." LHS students represented nations in both national costume and with athletic jerseys and flags as they made their way through Tacoma.

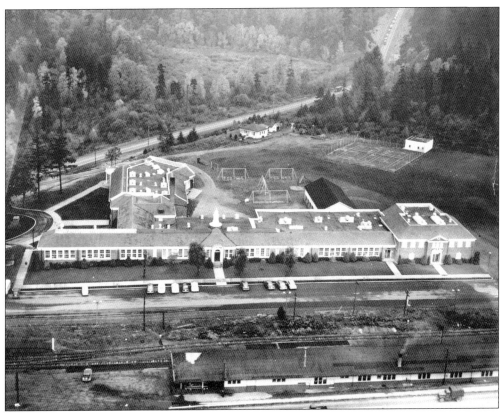

Laughbon High School's creation added to a conflict with Clover Park School District concerning jurisdiction over Fort Lewis schools that had begun in the 1950s. Enrollment was dwindling (in 1966, a total of 500 students left the area after their families were ordered off base while their fathers were deployed to Vietnam). In 1972, the state legislature ordered that one district handle the fort area, and a Pierce County committee selected Clover Park.

Trimmed of Fort Lewis students, only 77 elementary and junior high school students lived in the DuPont area. School was held for them in the former high school, but it proved too expensive to maintain. City College of Seattle and Evergreen Lutheran School used the building until its January 1989 demolition. This photograph shows the hallway between the assembly room and shop room, which went out to the playground, shortly before demolition.

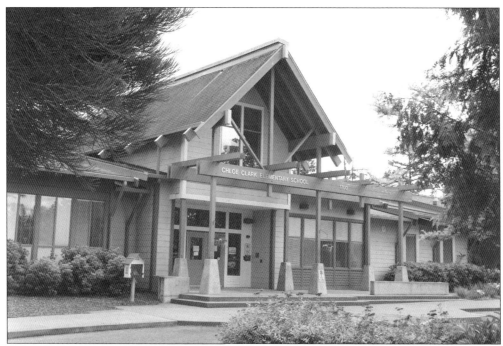

In 1975, the DuPont School District combined with Steilacoom and Anderson Island School Districts to form the Steilacoom Historical School District No. 1. Currently, there are two schools in DuPont—Chloe Clark Elementary School opened in 2001, and Pioneer Middle School in 2008. The elementary school, located at 1700 Palisade Boulevard, was named for early teacher Chloe Clark, who taught at the Nisqually Mission (1840–1841).

Pioneer Middle School, at 1750 Bob's Hollow Lane, was built in 2008. Its mascot is a pirate. After middle school, DuPont students attend Steilacoom High School. The old DuPont School has not been forgotten. Reunions of former DuPont School students began in 1988, just before the old school was torn down. The history of schools in DuPont is full of change. However, one constant has been a dedication to learning.

Six

MODERN CITY

In 1976, the DuPont Company explosives plant in DuPont closed down after 67 years of operation. A waning market for powdered explosives led to this decision. It was the end of an era and the beginning of much change for the community.

The Weyerhaeuser Company purchased the 3,200-acre plant site for $12 million. Originally, the new owner planned to establish an export facility on the property that would send wood products overseas. Environmental concerns and a drop in the world demand for wood products caused Weyerhaeuser to change its focus to land development in DuPont. The company's holdings were transferred to a subsidiary, the Weyerhaeuser Real Estate Company.

WRECO planned to create commercial, industrial, and residential areas in a development named Northwest Landing. A subsidiary of WRECO, Quadrant Homes, would build the houses. In 1989, the DuPont City Council approved this ambitious plan that would transform the town. However, taking care of the toxic waste left behind by decades of explosives manufacturing was a necessary first step. Weyerhaeuser and the DuPont Company entered into an agreement with the Washington State Department of Ecology to clean up the former DuPont Powder Works industrial site.

The remediation work took years to complete, with part of the area transformed into an 18-hole golf course, the Home Course, which opened in 2007. Numerous homes and businesses were built, along with the necessary infrastructure of roads, sewer, and water. In 2009, the DuPont city government moved from the historic DuPont Village to a new DuPont Civic Center in Northwest Landing. DuPont's population exploded, according to US census records, from 592 in 1990 to 8,199 in 2010.

DuPont has become a modern city complete with businesses, industry, residential areas, and amenities such as parks and a public library. At the same time, many people in the community have worked to preserve the area's unique heritage. These efforts are led by dedicated members of the DuPont Historical Society. Historic DuPont Village, with its well-preserved homes from the early DuPont Company era, remains an important part of DuPont along with Northwest Landing.

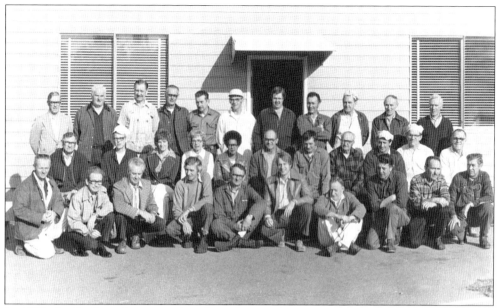

In 1976, the DuPont Company closed its plant in DuPont, Washington, ending decades of manufacturing in the area. Dynamite became obsolete with the invention of tovex gel, a safer explosive to manufacture. Some company workers remained at the plant into 1977 to wrap up operations. Pictured here on March 30, 1977, are some of the last workers at the DuPont plant.

The DuPont Company era left many memories. This photograph shows the DuPont Powder Works annual pensioners' dinner on December 2, 1977. Even today, a DuPont Old Timers Reunion for Historic DuPont Village residents and families meets annually for a time of fellowship and reminiscing.

Weyerhaeuser bought the plant site from the DuPont Company in 1976 and planned to use the land for exporting wood products. Changing markets and environmental issues caused Weyerhaeuser to concentrate instead on building a planned community called Northwest Landing. (Courtesy of Quadrant.)

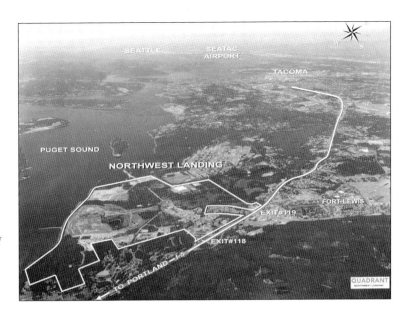

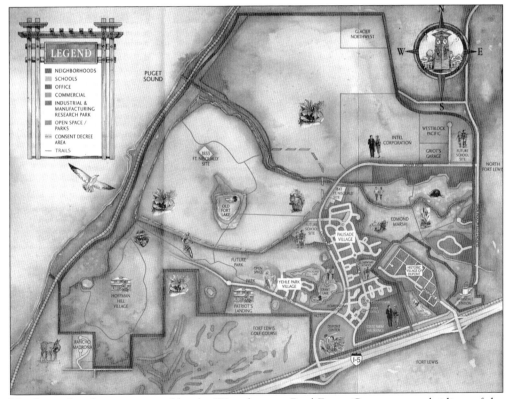

Northwest Landing was created by the Weyerhaeuser Real Estate Company, a subsidiary of the Weyerhaeuser Company. This ambitious development, as seen in this map, included residential, commercial, and industrial sections. An environmental cleanup of the former DuPont plant site in cooperation with the DuPont Company and the Washington State Department of Ecology was a key first step. Construction of Northwest Landing occurred in phases. (Courtesy of Quadrant.)

Life continued in DuPont during these years of change. This photograph is of the DuPont School float in a special centennial celebration parade in the community on July 4, 1989. The event honored the 100th anniversary of Washington becoming a state. Michael Marsh portrayed the teacher.

The old Johnson Brothers Store was renovated and then dedicated as the DuPont City Hall on October 6, 1990. For years, the building served as a school dormitory, apartment building, and a community gathering place. A cupola atop the structure came from the closed DuPont School.

Northwest Landing continued to be developed. Crucial to the project was the construction of sewer, water, and roads. Here, in 2003, workmen are building a sidewalk next to Center Drive in what would become Northwest Landing's downtown. Many of the new roads in the development received names related to DuPont's history.

Before Northwest Landing, only the DuPont Steilacoom Road exit (119) provided access to DuPont from Interstate 5. A second exit was needed for the city's expansion. This 1997 photograph shows an early stage in the building of the new Center Drive exit (118). It proved to be a massive project.

As the development of Northwest Landing proceeded, a downtown formed in the new part of DuPont. This 2003 photograph by Alex Crewdson shows the Farelli Pizza building under construction at 1590 Wilmington Drive.

A number of buildings took shape in the business section of Northwest Landing. Here, a June 2004 photograph features a street scene along Wilmington Drive.

Parks were not forgotten in developing DuPont. This photograph shows the building of the clock tower in Clocktower Park (1401 Palisade Boulevard) in August 1995. Other parks that were created in Northwest Landing include Bell Hill Park, Chief Leschi Park, DuPont Powderworks Park, Edmond Village Park, Pola Andre Park, and Ross Plaza.

Pictured is the completed clock tower in August 1995. The structure has become a landmark in DuPont. Many community events take place at Clocktower Park in the shadow of the clock tower, such as the Fourth of July celebration, Heritage Hudson's Bay Days, Kansas City BBQ Society Cookoff, National Night Out, and Concerts in the Park.

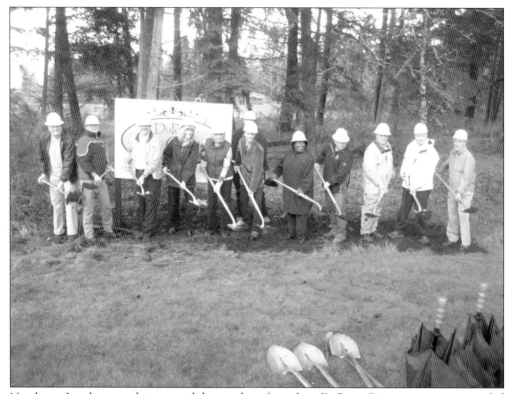

Northwest Landing greatly increased the number of people in DuPont. City government expanded to meet the demand for services, moving in 2009 from cramped quarters in the DuPont Village to a new DuPont Civic Center in Northwest Landing. Pictured here at the ground breaking are DuPont city councilmembers, city staff, and Helix Design Group employees. (Courtesy of Helix Design Group.)

The completed DuPont Civic Center, featured in this 2018 photograph, is the home of the DuPont city government and its various departments. Nearby, the DuPont Fire Department and DuPont Police Department are based in their own building, constructed in 2009.

The Lions Club has contributed much to DuPont. Since 2010, the DuPont Lions Club has worked on numerous community projects, including rebuilding DuPont's Clocktower Park arbors and assisting with constructing the public restroom, restoring DuPont's first fire truck, organizing annual food and blanket drives, and conducting sight and hearing tests for area school children. This picture shows the Lions Club booth at the Fourth of July Pancake Breakfast in 2018.

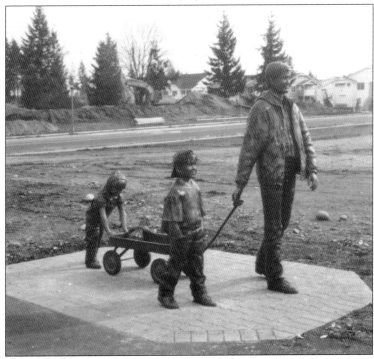

Public art is an important part of DuPont community life. Pictured here in March 1998 is the *Annie's Outing* sculptural group on Center Drive. A Raggedy Ann–style doll is riding in the toy wagon. Artist Judy Phipps Mickelson created this sculpture, which was donated by Quadrant to DuPont in 1998. *Annie's Outing* has become a community landmark.

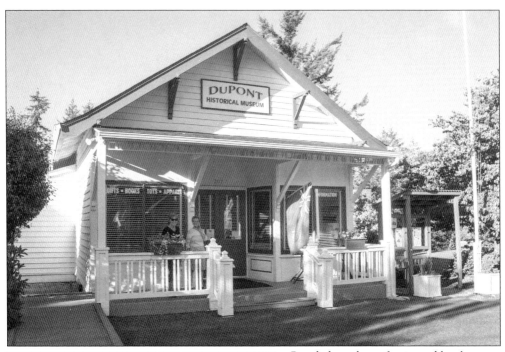

People have been fascinated by the area's interesting heritage. The DuPont Historical Museum, located at 207 Barksdale Avenue, opened in 1977 in a building that previously served as a meat market and the city hall. Museum exhibits tell the story of DuPont from Native American history through the construction of Northwest Landing. While the City of DuPont owns the museum's building, it is operated by the DuPont Historical Society.

Started in 1977, the DuPont Historical Society organized as a nonprofit corporation in 1982. Pictured here at a Cherry Blossom Tea in 2009 are Lorraine Overmyer (left) and Johanna Jones. When the DuPont plant was closing, Overmyer was a leading force in helping to rescue many of the artifacts visitors see in the museum today. Jones served as museum manager from 2006 to 2012 with enthusiasm and ability.

A narrow-gauge train moved materials and finished products at the DuPont Powder Works. After the plant's closure in 1976, some railroad equipment was saved and stored until the DuPont Historical Society could organize its reassembly near the museum. In this 2008 photograph, soldiers from the 593rd Sustainment Brigade at JBLM are bringing to DuPont a 12-ton Plymouth engine that was stored at the military base.

The train was put together behind the DuPont Historical Museum. Many people helped. Sen. Mike Carroll assisted in securing funding, Gary Lucas went door to door raising money, and Fred Foreman served as volunteer lead on the reassembling of the equipment. The *DuPont Dynamite Train* exhibit near the museum is an impressive reminder of the DuPont Company era. It is decorated annually for the Christmas season by community volunteers.

Every year, the DuPont Historical Society organizes a variety of public events. One such event, the Cherry Blossom Tea, started in 2008. This fun spring program, as seen in this 2017 photograph, combines food, fashion, and history. All proceeds of the tea benefit the DuPont Historical Museum to help protect, preserve, and promote the history of DuPont and the surrounding areas.

Another event in DuPont that demonstrates public support of heritage is the Fourth of July Pancake Breakfast. Forever Young Seniors began the pancake breakfast in 2002. Sponsored by the Northwest Landing Residential Owners Association, the annual event at Clocktower Park brings people together on the national holiday. Proceeds benefit the DuPont Historical Society and Museum. In recent years, much has changed in DuPont, but the sense of community remains.

About the Organization

The DuPont Historical Society's mission is to preserve, interpret, and promote the historical heritage of the city of DuPont and surrounding areas for present and future generations. A major focus is operating the DuPont Historical Museum.

This museum tells the story of the unique role that DuPont played in the development of Washington State and the Puget Sound region. Exhibits include displays and artifacts from the four eras of DuPont history beginning with the Native Americans, through the Hudson's Bay Company, to the DuPont Company, and finally Weyerhaeuser's planned community, Northwest Landing. The museum also features archival photographs, artifacts including tools used to manufacture dynamite, and a display entitled *Life in a Company Town: Yesterday and Today*.

Through leadership and education, the DuPont Historical Society will continue to preserve DuPont's rich cultural heritage by operating the DuPont Historical Museum and developing historic sites, resources, and visitor destinations.

For more about the DuPont Historical Society and the DuPont Historical Museum, call 253-964-2399, or email duponthistoricalmuseum@gmail.com. The museum is located at 207 Barksdale Avenue, DuPont, Washington 98327.

DISCOVER THOUSANDS OF LOCAL HISTORY BOOKS FEATURING MILLIONS OF VINTAGE IMAGES

Arcadia Publishing, the leading local history publisher in the United States, is committed to making history accessible and meaningful through publishing books that celebrate and preserve the heritage of America's people and places.

Find more books like this at
www.arcadiapublishing.com

Search for your hometown history, your old stomping grounds, and even your favorite sports team.

Consistent with our mission to preserve history on a local level, this book was printed in South Carolina on American-made paper and manufactured entirely in the United States. Products carrying the accredited Forest Stewardship Council (FSC) label are printed on 100 percent FSC-certified paper.